PAINTING WITH
WATER-SOLUBLE
COLORED PENCILS

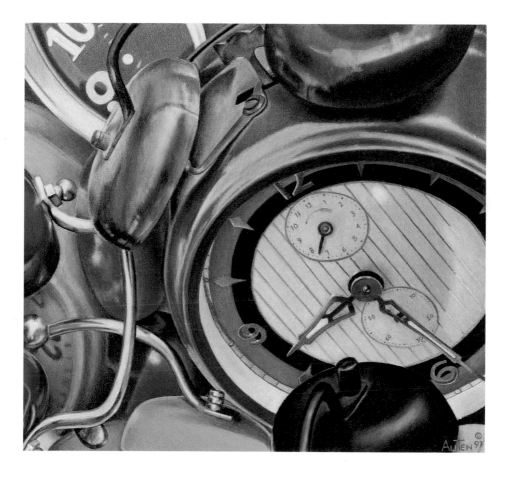

GARY GREENE

NORTH LIGHT BOOKS
CINCINNATI, OHIO

Painting With Water-Soluble Colored Pencils. Copyright © 1999 by Gary Greene. Manufactured in China. All rights reserved. No part of this book may be reproduced in any form or by any electronic or mechanical means including information storage and retrieval systems without permission in writing from the publisher, except by a reviewer, who may quote brief passages in a review. Published by North Light Books, an imprint of F&W Publications, Inc., 1507 Dana Avenue, Cincinnati, Ohio 45207. (800) 289-0963. First paperback edition 2002.

Other fine North Light Books are available from your local bookstore, art supply store or direct from the publisher.

06 05 04 03 02 5 4 3 2 1

Library of Congress has catalogued hardcover edition as follows:

Greene, Gary.
 Painting with water-soluble colored pencils / by Gary Greene.—1st ed.
 p. cm.
 Includes index.
 ISBN 0-89134-884-0 (hardcover)
 1. Colored pencil drawing—Technique. 2. Water-soluble colored pencils. I. Title.
NC892.G75 1999
741.2'4—dc21
ISBN-1-58180-295-1 (pbk. : alk. paper)

PP 49177
CIP

Editor: Glenn Marcum
Production editor: Michelle Howry
Production coordinator: John Peavler
Designer: Brian Roeth

ABOUT THE AUTHOR

In addition to being an accomplished fine artist, Gary Greene has been a graphic designer, technical illustrator and professional photographer since 1967. After working in a number of fine art mediums including acrylic, airbrush, graphite and ink, he discovered colored pencil in 1983 and it was love at first stroke!

Gary's techniques employ multicolored layers of colored pencil, burnished with light colored pencil between the layers until the entire paper surface is covered. He also underpaints with layers of colored pencil dissolved with solvent or water-soluble colored pencil washes. Some of Gary's larger paintings are 32″ × 40″ (80cm × 100) and may require 300-400 hours or more to complete. When people see his super-realistic paintings, they often remark, "That's colored pencil?!"

Gary is the author of *Creating Textures in Colored Pencil*, *Creating Radiant Flowers in Colored Pencil*, *Artist's Photo Reference: Flowers* and *Painting with Water-Soluble Colored Pencils*, all published by North Light Books. His colored pencil paintings have appeared in *The Artist's Magazine, American Artist, Creative Colored Pencil* (Rockport), *The Complete Colored Pencil Book*, (North Light), *The Encyclopedia of Colored Pencil* (Quarto), and *The Best of Colored Pencil 1, 2 and 3* (Rockport). He has also produced a colored pencil video entitled *Painting with Colored Pencil, Series 1.*

Gary's colored pencil paintings have won numerous national and international awards, including Honorable Mention in the Colyer-Weston Art League National Art Merit Competition, two Honorable Mentions in the 1994 and 1991 *The Artist's Magazine* National Art Competition and the Berol Award of Excellence at the Colored Pencil Society of America (CPSA) 1993 International Exhibition. His work has been purchased and showcased by corporations such as Lyra Bleistift-Fabrik (Germany), Paccar, Parsons Brinkerhoff and the Gango Gallery in Portland, Oregon.

Gary has conducted workshops, demonstrations and lectures in the United States and Canada since 1985. He is a Signature Member of the Colored Pencil Society of America and served on its Board of Directors from 1990 to 1996.

To Grace and George—
you light up my life like no human can.

ACKNOWLEDGMENTS

Without a doubt, first and foremost recognition goes to the creative and talented contributing artists: Bonnie Auten, Pat Averill, Rhonda Farfan, Shane, Dyanne Locati and Bernard Poulin. I chose these artists because I knew their skills and diversity of style would be a major factor in the success of this book. Thanks to them for their patience, professionalism and beautiful work, for which I will always be grateful.

Thanks to Werner Kring of Lyra, Chuck Cannon of Faber-Castell, Bob and Kathy Dix of Bruynzeel, and Jack Wayman of Strathmore Paper Company for providing their fine products to me and the contributing artists.

I'd also like to acknowledge the prompt and superb service from Dave, Dale, Kelley and all at Pro Lab. What could have been very difficult was easy because of you.

Once again, my sincerest thanks to Rachel Wolf for her confidence in me and thanks to Glenn Marcum, my editor, who will, I'm sure, make my twelfth grade grammatical skills look like I graduated summa cum laude from Oxford. He showed his confidence in my work by keeping a very low profile during the book's creation.

Finally, special thanks to my spouse, Patti, who for the fourth consecutive year, had to do my share of the housework and endure many evenings alone by the TV, while I toiled on the book.

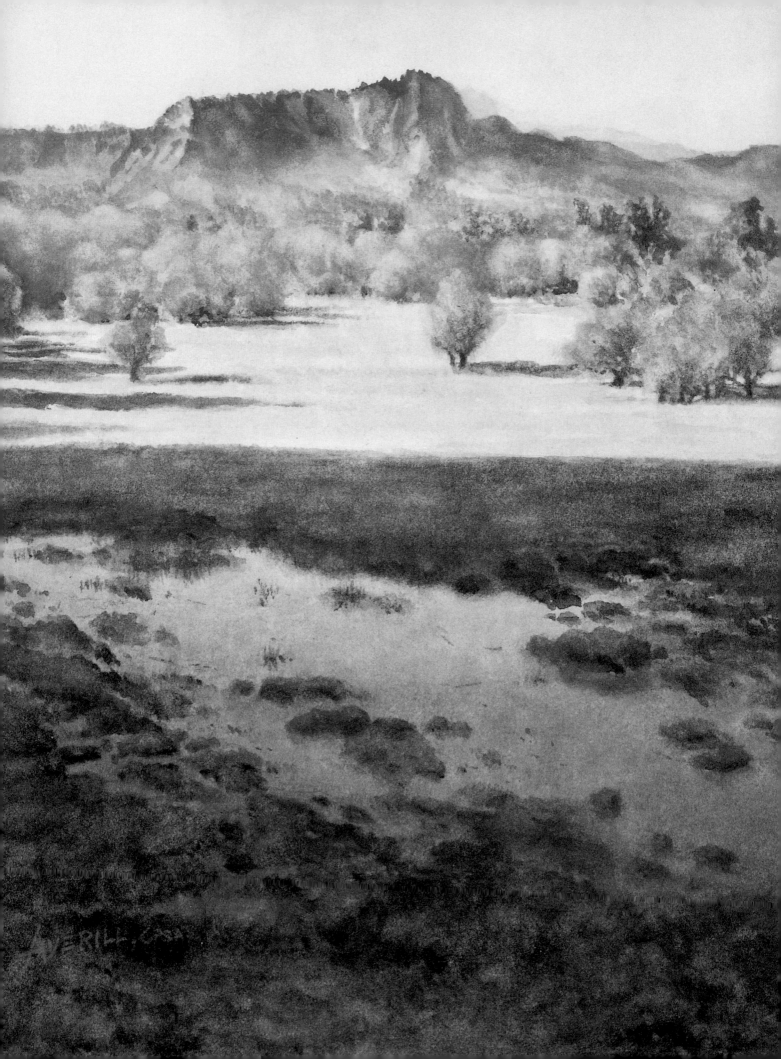

TABLE OF CONTENTS

FOREWORD

Colored pencil is a medium that is beginning to hit its stride in the art world. No longer thought of as a medium just for children, colored pencil art is showing up more and more in art exhibitions and galleries. There is now an organization, the Colored Pencil Society of America (CPSA) for colored pencil artists and aficionados. There are actually quite a few books available that deal with the numerous techniques used by colored pencil artists to render any number of subjects in any number of styles. Gary Greene has written two of them himself—*Creating Textures in Colored Pencil* and *Creating Radiant Flowers in Colored Pencil*. But there is more to colored pencil than meets the eye, and it is this "more" that Gary Greene has addressed in this book.

Almost all of the focus on colored pencil has been on the traditional wax- or oil-based varieties. Its "cousin," the seldom-acknowledged water-soluble colored pencil, has been virtually ignored. A few books mention its existence very briefly, but this book you now hold in your hands is the first genuine handbook to deal exclusively with the many techniques for using the water-soluble colored pencil.

As president of the CPSA, I've been asked frequently about water-soluble colored pencils. Until now, I had nothing to recommend as a reference for this aqueous medium. I could only tell people to "wing it"—to learn by trial and error.

Gary has filled a giant void with this book. He has created an easy-to-follow; step-by-step manual in the use of the water-soluble colored pencil. From tightly rendered procedures to free and loose techniques, you can let your imagination be your guide. The techniques in this book will add to your artistic repertoire while being just plain fun.

Whether you are a beginner, an instructor or an accomplished artist, Gary's book will lead you into the wet world of water-soluble colored pencils. I thank Gary for taking time from making his own amazing art to guide us on an exciting adventure. And to you, the reader, I say, "Bon Voyage!"

Rhonda Farfan
President, Colored Pencil Society of America

INTRODUCTION

When I took on this project, my experience with water-soluble colored pencils was limited to underpainting grounds for dry colored pencil texture studies. All the colored pencil artists I know had less knowledge of the medium. In the year it took to write and illustrate this book, I learned that there were almost an infinite range of possibilities to this fascinating medium. Water-soluble colored pencils have been around for a long time (heck, I remember Mongol pencils when I was a kid—now that was a long time ago!), but it seems no one knows how to use them and what their capabilities are.

As far as I know, this is the first book dedicated entirely to the use of water-soluble colored pencils. When you try the techniques in the book, your creative juices will flow in torrents like mine did. As you'll discover, water-soluble colored pencils lend themselves to any style—from a loose watercolor look to a tight airbrush style and everything in between. They can be combined with their sister wax- or oil-based colored pencils, applied dry or liquefied with solvents.

There are some that might say, "Why not just use watercolors?" My response is that water-soluble colored pencils are much more versatile than watercolors (Can you apply watercolors completely dry?) and they are easier to control. They're much less expensive than watercolors—you can have a vast range of colors at your fingertips without having to buy expensive tubes, some of which go unused and dry up. Water-soluble colored pencils are far more portable, take up less space, aren't messy and are easy to clean up. Finally, when you tell people your painting was done with water-soluble colored pencils, you'll really get their attention.

As in any other medium, don't expect perfection on your first try with water-soluble colored pencils. But with a little practice, you'll be not only creating exciting paintings but also inventing your own unique techniques.

Gary Greene
Woodinville, Washington
April, 1998

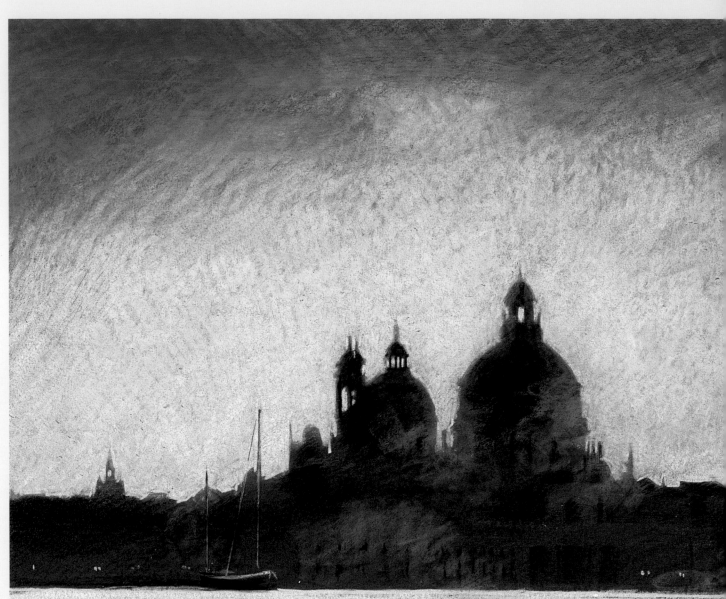

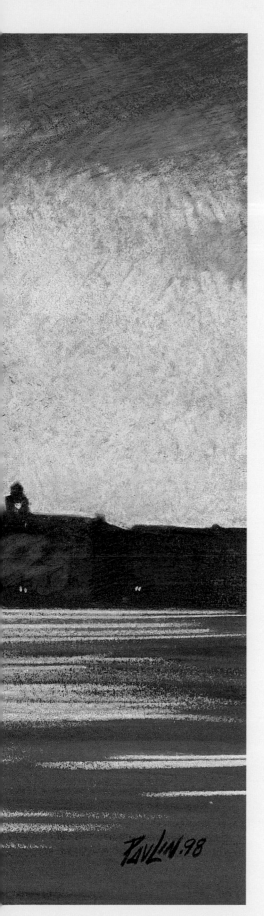

MATERIALS AND TOOLS

I'm frequently asked "What kind of pencils do you use?" My response is usually "Whatever color works!" When painting with water-soluble or traditional colored pencils, my first consideration is "What colors will I need to complete my project?" Since colored pencil manufacturers do not follow a "standard" for mixing pigments, artists have a large variety of colors to choose from, ranging from subtle to unique.

To cite a few examples, Caran d'Ache Supracolor II offers useful colors like (among others) Greyish Green, Green Ochre, Khaki Green and Light Olive. However, Caran d'Ache Fast Orange is almost identical to Lyra and Faber-Castell Orange-Yellow, and slightly redder than the Rexel Derwent Naples Yellow. In some cases, a color's nomenclature may be the same from brand to brand, but the hue will be noticeably different. Note the differences in Vermilion (see illustration on page 13). Variations in hue from brand to brand can be utilized by artists to add depth of color to their paintings unparalleled with most media.

VENICE SKYLINE
Bernard Poulin
9″ × 12″ (23cm × 30cm)
Wet-on-Dry 1 and Dry-on-Dry Technique

What Brand of Water-Soluble Pencil?

At this writing, the five brands used in this book represent the leading quality water-soluble colored pencils. Each have strong and weak "points" (no pun intended) within the following criteria:

COLOR RANGE

The Caran d'Ache Supracolor II Soft has the widest array of colors (120), followed by Faber-Castell Albrecht Dürer with 100 colors. Both Lyra Rembrandt Aquarell and Rexel Derwent have 72 different colors. Bruynzeel Design Aquarel has the fewest colors with 48. Faber-Castell intelligently groups its grays into Cold and Warm I–VI. Faber-Castell pencils have many similarities in color nomenclature with Lyra.

DRY APPLICATION

All brands except the Rexel Derwent pencils have a soft, creamy feel when applied dry, with the edge going to Faber-Castell Albrecht Dürer. Rexel Derwent pencils apply hard and dry, which requires repeated layering—this can be advantageous when many layers of colored pencil are required (see chapter two, *Techniques*).

WET APPLICATION

When water is added to dry water-soluble pencil, an amazing transformation occurs—the pigment instantly takes on the appearance of watercolor, gouache, acrylic or even oil, depending on the technique used. It's important to know how different water-soluble pencils react and look when they're wet.

Notice how the pigment dissolves when water is added with a brush. Faber-Castell Albrecht Dürer pencils dissolve most quickly and thoroughly, with the Rexel Derwent running a close second. The Bruynzeel pencils take a few more brushstrokes before they completely dissolve. This variation does not necessarily determine the quality of a water-soluble pencil.

COLOR SHIFT

The next thing to look for is the apparent color change, or "shift," that occurs when a pencil is wet. Color shift occurs because the pigment completely covers the paper surface when water is applied. When the pigment is dry, tiny specks of the bare surface show through, muting the color's intensity and, as in any liquid medium, making the color appear darker. Color shift is more noticeable with "strong" colors such as red, violet, indigo, dark versions of green, blue, etc.

Color shift also depends on the opacity of the pigment when it's wet. Of the five brands, Faber-Castell Albrecht Dürer pencils produce the most opaque coverage, followed by Rexel Derwent and Caran d'Ache Supracolor II. Lyra Rembrandt Aquarells are the most transparent and Bruynzeel Design Aquarels are a close second. In some cases, using an opaque pigment may be more desirable. In other cases, especially when layering and wetting colors separately, a transparent pigment will be a better choice.

LIGHTFASTNESS

Because colored pencils have enjoyed such tremendous growth in popularity with continuing demands of serious artists, manufacturers have begun to improve the quality of their products, especially in the area of lightfastness. Unfortunately, there is still a long way to go before colored pencils, and water-soluble pencils in particular, reach equality with finer watercolors and pastels. However, if colored-pencil artwork is handled with a modicum of common sense (i.e., keeping it out of direct sunlight), it should long outlive its creator.

Earth tones, grays, neutrals and some blues and greens test satisfactorily for lightfastness, but intense colors like reds, purples and flesh tones do not test as well. Manufacturers themselves rate the lightfastness of each color in their line, which is like the old cliché about the fox guarding the hen house. To get accurate, unbiased lightfastness test results, contact the product research director of the Colored Pencil Society of America (CPSA). Check which brand(s) test best for each color you use—all other considerations being nearly equal, this may be the determining factor for your choice of colored pencils.

> ### What's the difference between water-soluble and traditional dry colored pencils?
>
> Water-soluble, or aquarel, pencils are very similar to wax- or oil-based colored pencils. They both contain natural and synthetic pigments, fillers made of kaolin or talcum, and binders made from cellulose, waxes and water.
>
> The main difference between traditional dry colored pencils and water-soluble colored pencils is the use of an emulsifying wax. Dry colored pencils do not contain an emulsifier, whereas water-soluble pencils contain a special emulsifying wax that allows the core (or lead) to be dissolved with water.

Water-Soluble Colored Pencils

OVERALL QUALITY

All of the pencils used in this book are excellent quality. They sharpen (using an electric sharpener) without excessive breakage to the casing or lead and withstand pressure when applied to the paper surface. Bruynzeel leads are slightly thinner, and are therefore unable to take as much pressure as thicker leaded pencils. Rexel Derwent pencils also have a tendency to break more often because they seem to have less binder, probably accounting for their hard/dry application characteristics. Both Faber-Castell and Lyra pencil casings have a slightly larger diameter than standard electric pencil sharpener openings, which may require these pencils to be "broken in" (jammed into the sharpener) when first sharpened.

Unless you have an urgent desire to own one, avoid buying colored pencil sets packaged in fancy wooden boxes or other gimmicks, which needlessly add to the cost. One exception is the clever wooden stand Faber-Castell packages with their 100-color set of Albrecht Dürer water-soluble colored pencils. The stand is divided into three segments, each holding thirty-four pencils (you get an extra two graphite pencils with the set). Two sections are hinged together, allowing each section to be moved into any desired position. Pencils, when placed in the holes in the stand, are held in place by metal clips that prevent them from falling out, even if the entire assembly is turned upside down. Unfortunately, these stands are not sold separately!

AVAILABILITY

Because both "dry" and water-soluble colored pencils have steadily grown in popularity the past several years, an increasing number of new brands have been made available to artists, and more are on the way. Unfortunately, your local art store may not be aware of this growth, so they may not carry most of the brands mentioned in this book. You may need to special order pencils through your local art store, or if they are unable (or unwilling) to do this, mail order art supply stores are the solution, especially if you're not near a large metropolitan area. Through mail order catalogs or the Internet, you can buy pencils either by the set or individually (known as open stock).

I don't buy pencils by the set. Instead, I have one complete set of each brand, which I use for color reference only. Before starting a painting, I decide how many of each color I'll need, for example: three Lyra Indian Reds, three Faber-Castell Vermilions, two Caran d'Ache Khaki Greens, etc. Buying pencils this way is far more economical than buying sets with colors you may never use.

Will the Real Vermilion Please Stand Up?
(top to bottom) Rexell Derwent Watercolour, Bruynzeel Design Aquarel, Caran d'Ache Supracolor II, Faber-Castell Albrecht Dürer, Lyra Rembrandt Aquarell. Notice the five distinctive shades of Vermilion; the differences are made even more evident when wet. Opacity also varies from brand to brand, the Faber-Castell pencils being by far the most opaque.

Leading Water-Soluble Pencil Brands

BRAND	MANUFACTURER (Country)	COLOR RANGE	APPLICATION CHARACTERISTICS	COLOR SHIFT	OPACITY	PRICE	TRADITIONAL DRY COLORED PENCIL EQUIVALENT	COMMENTS
Design Aquarel	Bruynzeel (Holland)	48	Soft	Moderate	Transparent	Moderate	Fullcolor	Limited color range
Albrecht-Dürer	Faber-Castell (Germany)	100	Soft	Minimal	Opaque	Higher	Polychromos	100 pencil set has useful holder Best gray range Most opaque
Supracolor II	Caran d'Ache (Switzerland)	120	Soft	Minimal	Opaque	Higher	Pablo	Greatest color range Unique colors
Rembrandt Aquarell	Lyra (Germany)	72	Soft	Minimal	Transparent	Moderate	Polychromos	Good value for the money Most transparent
Rexel Derwent	Winsor & Newton (England)	72	Hard	Moderate	Opaque	Low	Artist/Studio	Hard leads

Color Charts

These charts depict the full color range of the five brands used throughout this book. The swatch on the left shows the color dry and the one on the right shows how the same amount of applied color looks after the color is liquefied with a medium-wet brush. Due to print reproduction limitations, some of the colors may not match the "real thing" and some of the subtleties in hue may be lost.

Faber-Castell Albrecht Dürer

101 White	141 Delft Blue	171 Light Green	190 Venetian Red
103 Ivory	137 Blue-Violet	170 Apple Green	192 Indian Red
102 Cream	136 Dark Violet	168 Moss Green	193 Burnt Carmine
104 Zinc Yellow	138 Violet	167 Sap Green	194 Purple
105 Cadmium Lemon	139 Light Violet	165 Juniper Green	124 Rose Carmine
106 Light Chrome	146 Sky Blue	158 Sea Green	130 Dark Flesh
107 Lemon	140 Ultramarine Light	159 Hooker's Green	131 Medium Flesh
108 Canary	120 Ultramarine	172 Grey-Green	132 Light Flesh
109 Orange-Yellow	143 Deep Cobalt Blue	173 Olive Green	270 Warm Grey I
111 Tangerine	144 Light Cobalt Blue	174 Cedar Green	271 Warm Grey II
113 Light Orange	147 Light Blue	175 Dark Sepia	272 Warm Grey III
115 Dark Orange	145 Light Phthalo Blue	177 Light Sepia	273 Warm Grey IV
117 Vermilion	152 Dark Phthalo Blue	176 Van Dyke Brown	274 Warm Grey V
118 Scarlet Lake	110 Azure Blue	178 Nougat	275 Warm Grey VI
121 Light Geranium Lake	151 Prussian Blue	180 Raw Umber	230 Cold Grey I
126 Dark Carmine	149 Oriental Blue	179 Bister	231 Cold Grey II
127 Light Carmine	155 Night Green	182 Brown Ochre	232 Cold Grey III
133 Wine Red	153 Peacock Blue	183 Gold Ochre	233 Cold Grey IV
123 Fuchsia	154 Aquamarine	185 Light Ochre	234 Cold Grey V
128 Rose Madder Lake	156 Blue-Green	184 Ochre	235 Cold Grey VI
129 Pink Madder Lake	161 Viridian	186 Terracotta	199 Black
125 Dark Magenta	162 True Green	187 Burnt Ochre	099 Soft Black
119 Light Magenta	163 Emerald Green	188 Sanguine	250 Gold
134 Magenta	112 Leaf Green	189 Cinnamon	251 Silver
135 Red-Violet	166 Grass Green	191 Pompeian Red	252 Copper

Caran d'Ache Supracolor II

085 Bordeaux Red	018 Olive Grey	150 Sapphire Blue	067 Mahogany
089 Dark Carmine	019 Olive Black	260 Blue	043 Brownish Orange
080 Carmine	039 Olive Brown	169 Marine Blue	055 Cinnamon
075 Indian Red	249 Olive	140 Ultramarine	037 Brown Ochre
280 Ruby Red	225 Moss Green	159 Prussian Blue	035 Ochre
070 Scarlet	220 Grass Green	149 Night Blue	059 Brown
060 Vermilion	460 Peacock Green	130 Royal Blue	045 Van Dyke Brown
050 Flame Red	201 Veronese Green	139 Indigo Blue	049 Umber
040 Reddish Orange	215 Greyish Green	120 Violet	407 Sepia
030 Orange	290 Empire Green	131 Periwinkle Blue	047 Bister
300 Fast Orange	210 Emerald Green	110 Lilac	404 Brownish Beige
031 Orangish Yellow	200 Bluish Green	099 Aubergine	405 Cocoa
032 Light Ochre	239 Spruce Green	111 Mauve	403 Beige
033 Golden Ochre	229 Dark Green	100 Purple-Violet	402 Light Beige
020 Golden Yellow	211 Jade Green	091 Light Purple	401 Ash Grey
010 Yellow	195 Opaline Green	090 Purple	002 Silver Grey
021 Naples Yellow	190 Greenish Blue	350 Purplish Red	003 Light Grey
240 Lemon Yellow	180 Malachite Green	270 Raspberry Red	004 Steel Grey
250 Canary Yellow	181 Light Malachite Green	082 Rose Pink	005 Grey
011 Pale Yellow	191 Turquoise Green	081 Pink	006 Mouse Grey
241 Light Lemon Yellow	171 Turquoise Blue	071 Salmon Pink	007 Dark Grey
491 Cream	170 Azure Blue	051 Salmon	008 Greyish Black
231 Lime Green	160 Cobalt Blue	493 Granite Rose	495 Slate Grey
221 Light Green	371 Pale Bluish	041 Apricot	409 Charcoal Grey
230 Yellow-Green	161 Light Blue	053 Hazel	496 Ivory Black
470 Spring Green	141 Sky Blue	062 Venetian Red	009 Black
245 Light Olive	151 Pastel Blue	063 English Red	001 White
015 Olive Yellow	155 Blue Jeans	065 Russet	498 Silver
025 Green Ochre	145 Bluish Grey	057 Chestnut	499 Gold
016 Khaki Green	370 Gentian Blue	069 Burnt Sienna	497 Bronze

Bruynzeel Design Aquarel

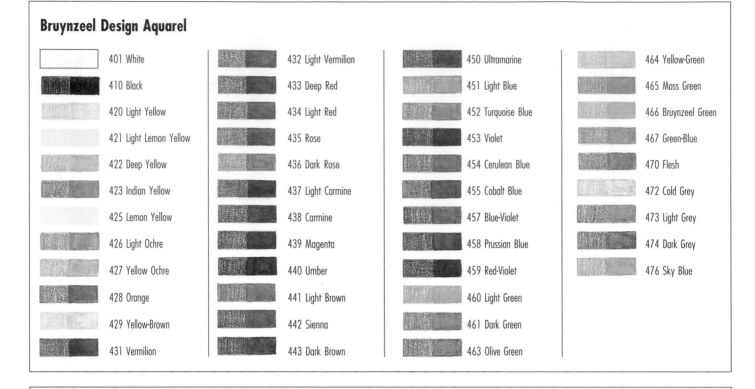

401 White	432 Light Vermilion	450 Ultramarine	464 Yellow-Green
410 Black	433 Deep Red	451 Light Blue	465 Moss Green
420 Light Yellow	434 Light Red	452 Turquoise Blue	466 Bruynzeel Green
421 Light Lemon Yellow	435 Rose	453 Violet	467 Green-Blue
422 Deep Yellow	436 Dark Rose	454 Cerulean Blue	470 Flesh
423 Indian Yellow	437 Light Carmine	455 Cobalt Blue	472 Cold Grey
425 Lemon Yellow	438 Carmine	457 Blue-Violet	473 Light Grey
426 Light Ochre	439 Magenta	458 Prussian Blue	474 Dark Grey
427 Yellow Ochre	440 Umber	459 Red-Violet	476 Sky Blue
428 Orange	441 Light Brown	460 Light Green	
429 Yellow-Brown	442 Sienna	461 Dark Green	
431 Vermilion	443 Dark Brown	463 Olive Green	

Lyra Rembrandt Aquarell

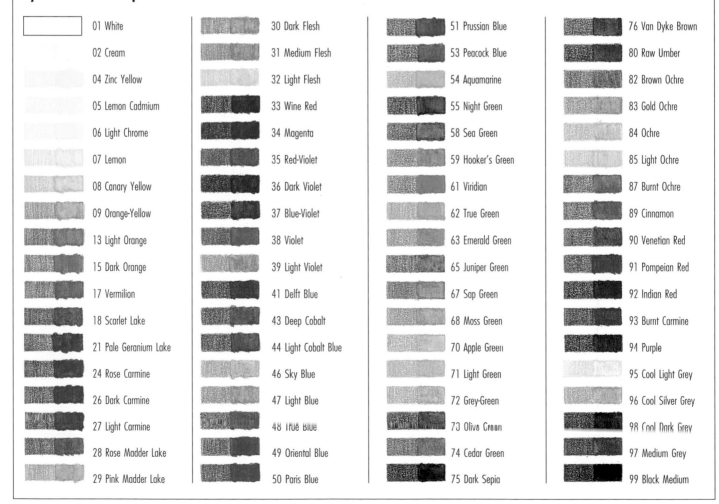

01 White	30 Dark Flesh	51 Prussian Blue	76 Van Dyke Brown
02 Cream	31 Medium Flesh	53 Peacock Blue	80 Raw Umber
04 Zinc Yellow	32 Light Flesh	54 Aquamarine	82 Brown Ochre
05 Lemon Cadmium	33 Wine Red	55 Night Green	83 Gold Ochre
06 Light Chrome	34 Magenta	58 Sea Green	84 Ochre
07 Lemon	35 Red-Violet	59 Hooker's Green	85 Light Ochre
08 Canary Yellow	36 Dark Violet	61 Viridian	87 Burnt Ochre
09 Orange-Yellow	37 Blue-Violet	62 True Green	89 Cinnamon
13 Light Orange	38 Violet	63 Emerald Green	90 Venetian Red
15 Dark Orange	39 Light Violet	65 Juniper Green	91 Pompeian Red
17 Vermilion	41 Delft Blue	67 Sap Green	92 Indian Red
18 Scarlet Lake	43 Deep Cobalt	68 Moss Green	93 Burnt Carmine
21 Pale Geranium Lake	44 Light Cobalt Blue	70 Apple Green	94 Purple
24 Rose Carmine	46 Sky Blue	71 Light Green	95 Cool Light Grey
26 Dark Carmine	47 Light Blue	72 Grey-Green	96 Cool Silver Grey
27 Light Carmine	48 True Blue	73 Olive Green	98 Cool Dark Grey
28 Rose Madder Lake	49 Oriental Blue	74 Cedar Green	97 Medium Grey
29 Pink Madder Lake	50 Paris Blue	75 Dark Sepia	99 Black Medium

Rexel Derwent Watercolour

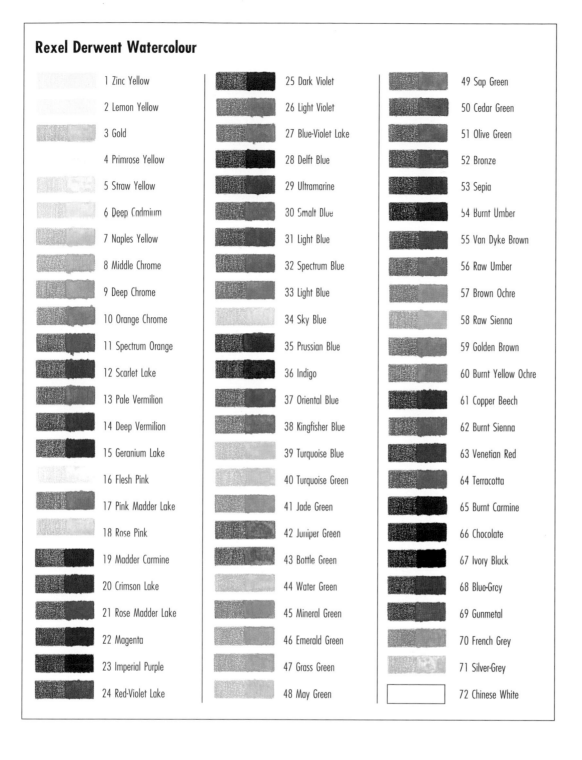

1 Zinc Yellow	25 Dark Violet	49 Sap Green
2 Lemon Yellow	26 Light Violet	50 Cedar Green
3 Gold	27 Blue-Violet Lake	51 Olive Green
4 Primrose Yellow	28 Delft Blue	52 Bronze
5 Straw Yellow	29 Ultramarine	53 Sepia
6 Deep Cadmium	30 Smalt Blue	54 Burnt Umber
7 Naples Yellow	31 Light Blue	55 Van Dyke Brown
8 Middle Chrome	32 Spectrum Blue	56 Raw Umber
9 Deep Chrome	33 Light Blue	57 Brown Ochre
10 Orange Chrome	34 Sky Blue	58 Raw Sienna
11 Spectrum Orange	35 Prussian Blue	59 Golden Brown
12 Scarlet Lake	36 Indigo	60 Burnt Yellow Ochre
13 Pale Vermilion	37 Oriental Blue	61 Copper Beech
14 Deep Vermilion	38 Kingfisher Blue	62 Burnt Sienna
15 Geranium Lake	39 Turquoise Blue	63 Venetian Red
16 Flesh Pink	40 Turquoise Green	64 Terracotta
17 Pink Madder Lake	41 Jade Green	65 Burnt Carmine
18 Rose Pink	42 Juniper Green	66 Chocolate
19 Madder Carmine	43 Bottle Green	67 Ivory Black
20 Crimson Lake	44 Water Green	68 Blue-Grey
21 Rose Madder Lake	45 Mineral Green	69 Gunmetal
22 Magenta	46 Emerald Green	70 French Grey
23 Imperial Purple	47 Grass Green	71 Silver-Grey
24 Red-Violet Lake	48 May Green	72 Chinese White

Paper Surfaces

When selecting a paper surface, avoid "bargains"—inferior paper may result in your painting turning out to be something you didn't bargain for. Always buy paper made from cotton fiber (rag paper) and paper that's pH balanced or acid free. Acid-free rag paper resists yellowing and deterioration over time, and is a must if you intend to sell your paintings.

WEIGHT

Thicker papers are less likely to buckle and are more durable, making them easier to work with. Paper thickness is denoted by weight or ply. A paper's weight is determined by how much a ream (500 sheets) of paper weighs. For example, if 500 sheets of paper weigh 140 pounds, it's called 140-lb. (300gsm) paper. Density and moisture content also determine the paper's weight—a dense 140-lb. paper may be slightly thinner than a porous 140 lb. pound paper. Two popular weights are 140-lb. (300gsm) and 300-lb. (640gsm) paper.

PLY

Ply also describes a paper's thickness. Two-ply paper means that two sheets of single-ply paper are laminated together, resulting in a thicker, more durable sheet. As layers of paper are added (usually in even numbers), the ply rating is increased (e.g., four-ply, eight-ply, etc.). If you use lots of water on your painting, use a thicker or heavier weight paper to minimize curling or buckling.

PAPER TYPES

Full-sheet watercolor paper is usually 22″ × 30″ (56cm × 76cm). There are three types: hot-press, cold-press and rough. Hot-press paper is smooth, dense and suited for tight, detailed paintings with crisp edges. Because of the paper's density and smoothness, the pigment sits on top of the paper surface; this paper does not hold up well to a lot of manipulation with brush, pencil or water. Cold-press paper has a texture or "tooth" and is more porous than hot-press paper. It absorbs more water, producing a looser looking painting style. Rough paper is exactly what the name implies—rough and po-

Hot-Press

Cold-Press

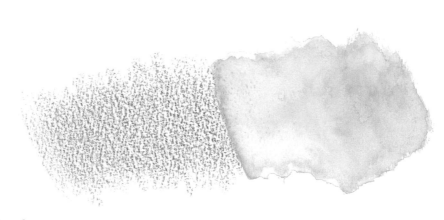

Rough
All three examples are on 140-lb. (300gsm) Strathmore Lanaquarelle.

rous. This paper can withstand repeated applications of water and removal of pigment without substantial damage to the paper surface. It is best suited for loose, watery looking paintings.

Brushes/Applicators

A good starting point for painting with water-soluble pencil would be a selection of quality, round watercolor brushes. As you explore more complex techniques and develop your style, almost any type of brush can be used to fulfill your creative needs.

To vary the look of your paintings, try using cotton swabs, cotton balls, foam-tipped brushes or sponges to apply water or pigment. Spraying layers of dry pencil with an atomizer or spray bottle also produces interesting effects.

PENCIL SHARPENERS

Pencil sharpeners are available in three types: manual, battery-operated (cordless) and electric (corded). Manual sharpeners are either small, hand-held models (which may or may not have a container to catch shavings) or office models (sharpeners that are attached to a desk or wall and equipped with a crank). Battery-operated models are small, cordless sharpeners. Corded electric sharpeners are larger and more durable.

Each type has its advantages and disadvantages. Small, hand-held sharpeners are messy if they don't have a container to collect shavings, and they are obviously slower to operate than electric models. Most importantly, they can cause serious injury to your hand from the repetitive motion required to sharpen pencils. "Office" or crank-operated sharpeners are also cumbersome and slow.

Electric sharpeners are designed for graphite pencils and have very short lives when continually used with colored pencils. Debris becomes lodged in the sharpening mechanism, causing it to burn out in a relatively short time. There's really no satisfactory solution to this problem, and because mechanisms in electric sharpeners are similar, an economically priced electric or battery-operated sharpener may be a better buy than a more expensive corded model. The ideal solution is to have two electric sharpeners: a battery-operated model for travel and a corded sharpener for your studio.

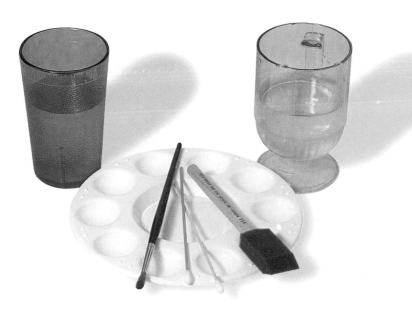

Tools for Applying Water-Soluble Colored Pencil
containers for water, palette, mop brush, cotton swabs, round watercolor brush.

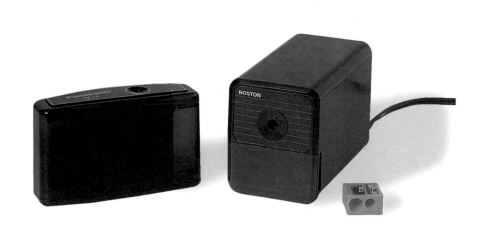

Pencil Sharpeners
(left to right) battery-operated, AC plug-in, manual hand-held.

Erasers

Erasers play an important role when painting with water-soluble pencils, but if you expect them to completely remove all traces of colored pencil mistakenly applied to your work of art, you're going to be disappointed. Like standard dry colored pencils, water-soluble colored pencils cannot be completely removed without damaging the surface they are applied to, regardless of whether the pencil is liquefied or dry. There is a stipulation to this, however: If you paint on cold-press or rough watercolor paper, the liquefied pigment can be efficiently removed by rewetting it and scrubbing gently with a soft-bristled wet toothbrush, cotton swab or rag. The paper actually *is* damaged, but because cold-press and rough watercolor papers are so porous, the damage is not as invasive, allowing reapplication of color and rewetting. Rough paper can be worked more extensively than cold-press paper because it's far rougher and more porous.

Kneaded erasers, long a staple of colored pencil artists, perform adequately for dry pencil but are woefully inefficient after the pigment is liquefied then dried. (*Never* attempt erasing when the surface is still wet!) Imbibed and white vinyl erasers perform better, particularly when used in an electric eraser, but still do not budge stubborn liquefied/dried color. Although an ink eraser will remove most of the liquefied/dried pigment, it will damage the paper surface so severely that it will be impossible to reapply color.

The unforgiving nature of water-soluble colored pencil, especially after wetting, may be considered a negative, but it will teach you to give more care and time to planning your artwork.

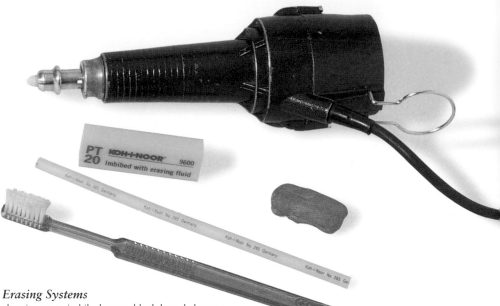

Erasing Systems
electric eraser, imbibed eraser block, kneaded eraser, imbibed eraser strip for electric erasers, toothbrush.

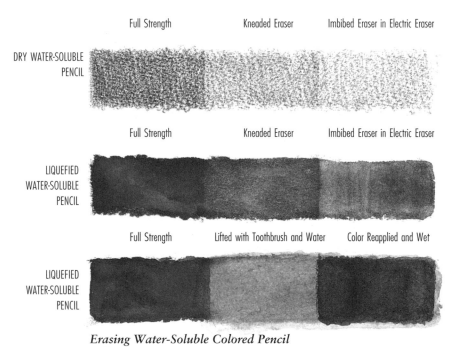

Erasing Water-Soluble Colored Pencil
In this illustration, a strong color was used on cold-press watercolor paper to demonstrate the effects of various erasing techniques on dry and liquefied water-soluble pencil pigment.

TOOLS OF THE TRADE

Pencil Extenders. When your pencil becomes too short to hold comfortably, a pencil extender can be attached to the end of the pencil.

Graphite Pencils. These are used for layouts (see chapter two, *Techniques*). It's important to use soft pencils such as B, 2B or 3B, because harder leads can impress a permanent line into the paper surface.

Hair Dryer. A good hair dryer will help to speed up your painting. Choose a compact model that has settings for high and low.

Debris Removal System. Colored pencils give off varying amounts of debris or crumbs depending on the brand or color. The paper surface should always be kept clear of debris with a tool such as a drafter's brush. Canned air, although expensive, is the ultimate debris remover because it prevents anything from touching your art. Never use your breath to blow debris from your art, especially when using water-soluble pencils—you may accidentally expectorate on pigment that is not intended to be wet!

MASKING

Masking materials come in solid and liquid form. Frisket paper is similar to heavy tracing paper with adhesive on one side. The frisket paper is laid on top of the surface you want to mask and adhered to the surface with a burnishing tool or brayer. The frisket is cut with a sharp X-Acto knife, then excess frisket around the masked area is removed and discarded.

Frisket is available in high-tack and low-tack versions. High-tack frisket paper is best suited to mask surfaces that cannot be pulled up, such as a Masonite panel. It adheres snugly to the surface, resisting paint from bleeding underneath. High-tack frisket is not recommended for use with paper or previously painted surfaces because its strong adhesive can pull up the surface, damaging it irreparably.

Low-tack frisket paper is a lot less sticky than high tack and removes easily from painted and raw paper surfaces without damaging them. It's important to secure it to the surface with a burnishing tool or brayer before cutting the mask.

Liquid frisket is actually a viscous material that is applied directly to the paper surface with a small brush. (Never use a good watercolor brush with liquid frisket!) It dries into a rubbery material that blocks the medium from where it's applied. Removing liquid frisket requires tweezers or the point of an X-Acto blade to pull off the mask. If you haven't applied enough liquid frisket, it can stubbornly cling to the surface of the paper, making it very difficult and frustrating to remove. For this reason, the use of liquid frisket should be limited to small areas.

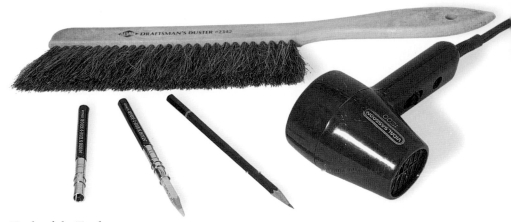

Tools of the Trade
(clockwise) desk brush, hair dryer, graphite pencil, pencil extenders.

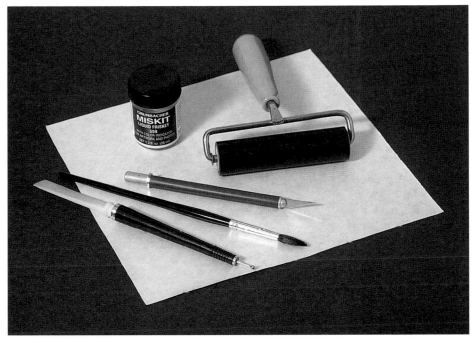

Masking Tools and Materials
(left to right) frisket paper, liquid frisket, brayer, X-Acto knife, inexpensive round brush, burnishing tool.



TECHNIQUES

This chapter will open your eyes to the versatility of water-soluble pencils. The techniques we'll explore are a mere sampling of what can be achieved with this exciting medium. From tight, super-realistic renderings to liquid impressionistic paintings, you can do it all with water-soluble colored pencils. Add dry colored pencils to the mix, and you'll be adding a whole new galaxy of tricks.

A pair of Rainier cherries was chosen as a simple subject and painted in the same style (but using different techniques) to demonstrate the differences and similarities in the look of each technique.

Sheets of 8 1/2" × 11" (22cm × 28cm) Strathmore Lanaquarelle 140-lb. (300gsm) cold-press watercolor paper and round sable watercolor brushes were used in each of the demonstrations.

LUNCH BREAK
Rhonda Farfan
20" × 24" (50cm × 60cm)
Wet-on-Dry Technique 3

WET-ON-DRY TECHNIQUE 1

Layer the colors dry at the same time on dry paper, then wet with a brush.

Most artists who have tried water-soluble pencils have used this technique. As shown in the illustration, the cherry on the left has been completely colored with dry water-soluble pencil. Next, a medium amount of water is added with a no. 4 watercolor brush. To avoid contamination, the yellow areas are wet first, then worked into the stronger red areas. Although the illustration shows the stem, fruit and shadow colored all at once, each section should be completed separately to avoid contamination and muddying, particularly where the blue-gray shadow meets the bottom of the cherry. Either a realistic or a loose look can be achieved using this technique.

Color Palette

All pencils in the technique demonstrations are Lyra Rembrandt Aquarell.

- Brown Ochre
- Cream
- Dark Carmine
- Dark Orange
- Medium Grey
- Ochre
- Pale Geranium Lake
- Sap Green
- Scarlet Lake
- True Blue
- Van Dyke Brown
- Vermilion

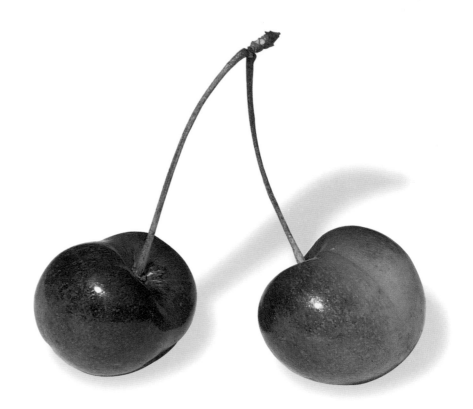

Our subject: Rainier cherries.

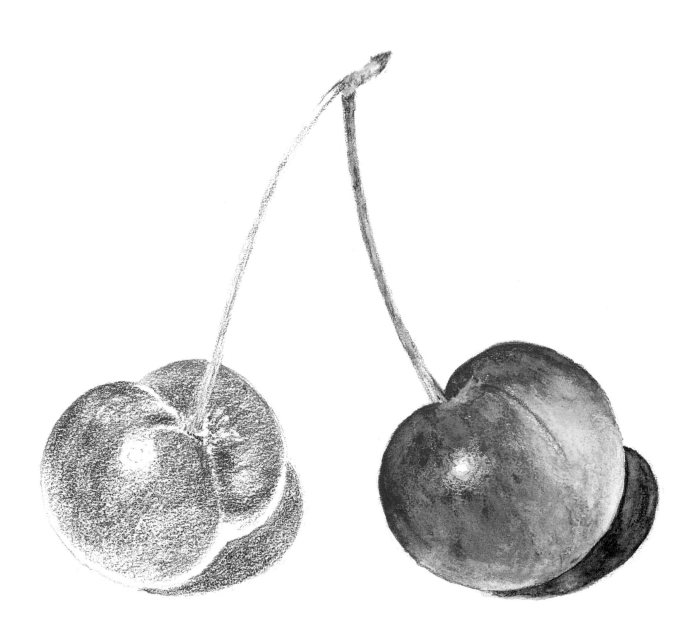

PROCEDURE

Cherries

1 Layer with dry Brown Ochre, Dark Carmine, Scarlet Lake, Pale Geranium Lake, Vermilion, Dark Orange and Ochre pencils. Leave the highlight areas free of color.

2 Apply water with a moderately wet no. 4 brush, starting with yellow areas first and working toward the red areas. Leave the highlights free of color and drag the lighter applications of color into areas with secondary highlights.

3 Dry with a hair dryer.

Stems

4 Layer with dry Van Dyke Brown and Brown Ochre pencils. Lightly layer with dry Sap Green and Cream pencils.

5 Apply water with a nearly dry no. 2 brush.

6 Dry with a hair dryer.

Shadows

7 Layer with dry Medium Grey, True Blue and Vermilion pencils, as shown.

8 Apply water with moderately wet no. 4 brush, starting with the blue side of shadow, working to the red side.

9 Dry with a hair dryer.

WET-ON-DRY TECHNIQUE 2

Wet each layer of dry water-soluble pencil separately on dry paper.

This wet-on-dry technique differs from the preceding in that it involves applying colors one at a time with dry pencils, then wetting and drying each color separately. This enables you to exercise more control over where the color goes, resulting in a more realistic effect. As with wax- or oil-based colored pencil techniques, start with the darkest value of the particular area to be painted (in this case, the Brown Ochre on the right side of both cherries). Brown Ochre is painted first because it is the darkest value of the Ochre area and we want to complete the Ochre area before applying red to prevent contamination with the stronger red hues.

By working one layer at a time, you have more control over your painting, which gives a "tight" or realistic look.

PROCEDURE

Cherries

1 Layer with a dry Brown Ochre pencil.

2 Apply water with a moderately wet no. 4 brush, pulling color outward to create a gradation. Dry with a hair dryer.

3 Layer with a dry Ochre pencil.

4 Apply water with a moderately wet no. 6 brush. Dry with a hair dryer.

5 Layer with a dry Dark Carmine pencil as shown.

6 Apply water with a moderately wet no. 4 brush. Dry with a hair dryer.

7 Layer with dry Dark Carmine, Scarlet Lake, Pale Geranium Lake, Vermilion and Dark Orange pencils.

8 Dab with a moderately dry no. 4 brush. Dry with a hair dryer. Repeat steps 5–8 as necessary.

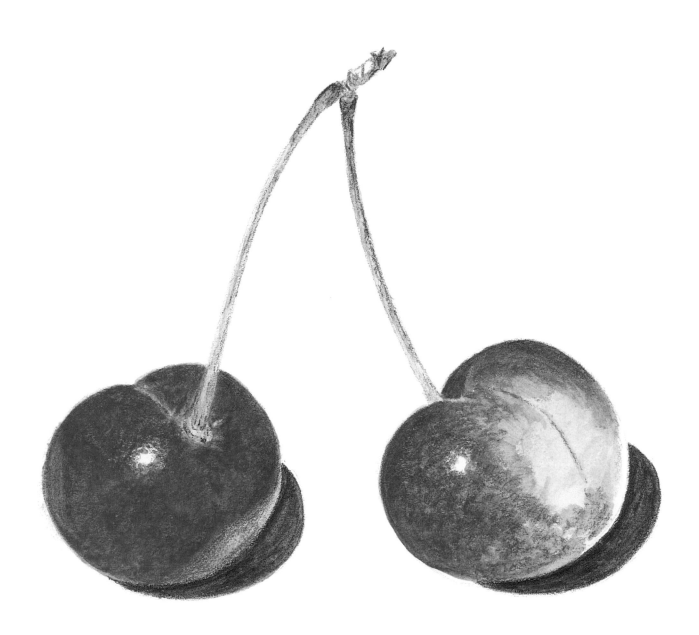

Stems

9 Lightly layer with a dry Sap Green pencil. Apply water with a nearly dry no. 2 brush.

10 Lightly layer with a dry Cream pencil. Apply water with a nearly dry no. 2 brush.

11 Lightly layer with a dry Van Dyke Brown pencil. Apply water with a nearly dry no. 2 brush.

12 Lightly layer with a dry Brown Ochre pencil. Apply water with a nearly dry no. 2 brush.

13 Relayer with a dry Van Dyke Brown pencil as shown. Apply water with a nearly dry no. 2 brush.

Shadows

14 Layer with a dry Medium Grey pencil. Apply water with a medium-wet no. 3 brush.

15 Layer with a dry True Blue pencil. Apply water with a medium-wet no. 3 brush.

16 Layer with a dry Vermilion pencil. Apply water with a medium-wet no. 3 brush.

17 Lightly relayer with a dry Medium Grey pencil. Apply water with a medium-wet no. 3 brush.

WET-ON-DRY TECHNIQUE 3

Apply color with a wet brush on dry paper.

Taking color from a water-soluble pencil point with a wet brush produces the same results as using a tin of watercolors. Wetting broken pencil points, letting them stand for about thirty minutes and applying the dissolved pigment to the dry paper will give the same look and feel as using watercolors from a tube. Both methods are used in this demonstration, which yields intense color and a realistic, somewhat loose look.

PROCEDURE

Cherries

1 Using either method described above, apply Brown Ochre to the appropriate areas with a no. 4 brush, wiping off the excess water. Add a small amount of water to soften the edge and to graduate value.

2 After allowing the Brown Ochre to dry somewhat (but not completely), apply Ochre, as in step 1.

3 Repeat procedure as before, dabbing small amounts of Dark Carmine, Scarlet Lake, Pale Geranium Lake and Vermilion, leaving highlight areas free of color.

4 Repeat adding color, until desired effect is achieved.

Stems

5 Carefully apply small amounts of Sap Green with a no. 2 brush. Carefully spread and thin the color evenly over the entire stem with clear water.

6 While step 5 is damp, apply small amounts of Van Dyke Brown. Spread and thin with clear water.

7 While step 6 is still damp, reapply Van Dyke Brown and apply Brown Ochre.

8 When nearly dry, apply a light coat of Cream.

Shadows

9 Apply Medium Grey with no. 4 brush.

10 While still wet, apply True Blue and Vermilion as shown. Repeat until the desired effect is achieved.

WET-ON-WET TECHNIQUE 1

Use a wet water-soluble pencil and brush on wet paper.

You must work fast with this technique. Because there is an intermingling of color while the paper surface is still wet, the color palette for the cherry body is reduced from seven colors to five: Brown Ochre, Ochre, Dark Carmine, Scarlet Lake and Vermilion. Apply color with the side of the pencil point, after dipping it into water, to prevent damaging the paper surface. When taken directly from the pencil, the color is intense but is moderated as it's brushed on the wet surface. This technique gives your painting a loose look.

PROCEDURE

Cherries

1 Using clear water, wet one cherry body with a no. 6 brush. Be sure to work on a flat surface to prevent puddling.

2 Dip a Brown Ochre pencil into water and apply it to a wet paper surface.

3 Spread color with a no. 4 brush moistened with clear water (the amount of water will determine the strength of the color).

4 Repeat steps 2 and 3 with Dark Carmine, Scarlet Lake and Vermilion.

5 Leaving the highlights free of color, lightly dab around them with a dry cotton swab.

6 Create secondary highlights on the sides of the cherry by lightly wiping with a cotton swab.

7 Air dry to prevent running.

8 Remove the hard edges by lightly layering the applicable color and wetting it with a nearly dry no. 0 brush.

Stems

9 Wet the stem area, as in step 1, with a no. 2 brush.

10 Apply wet Van Dyke Brown pencil as shown. Blend with a small, wet brush.

11 Repeat step 10 with Brown Ochre, Sap Green and Cream.

Shadows

12 Wet the shadow areas with a no. 4 brush.

13 Apply a wet Medium Grey pencil. Blend with a small, wet brush.

14 Repeat step 13 with True Blue and Vermilion.

15 Clean up the edges by lightly layering applicable color(s) with a dry pencil and wetting with a small, nearly dry brush.

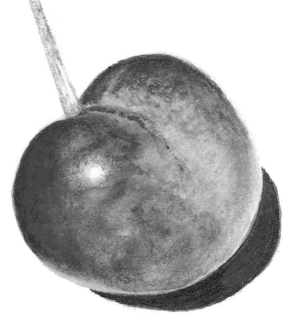

WET-ON-WET TECHNIQUE 2

Apply color with a wet brush on wet paper.

With this demonstration, it would be difficult for anyone to discern the difference between using actual watercolors and water-soluble colored pencils. Realistically it is a watercolor painting, but instead of pigment coming from a tube or tin, it is taken from a water-soluble colored pencil. Take a wet brush to a sharpened pencil point, then apply the color to the moistened paper. You can also break off points into a plastic palette, drop some water on them, wait until they completely soften, then apply the pigment to your painting.

This technique gives a truly loose watercolor look to your painting. It also requires a little practice to achieve results, but the effort will be worthwhile! The color palette was limited to allow for more spontaneity.

PROCEDURE

This is the same as Wet-on-Wet Technique 1 with pencil and brush, except the pigment is picked up from the pencil with a wet brush and applied to the wet paper surface. The cherry body palette is limited to Brown Ochre, Ochre, Dark Carmine and Vermilion.

Cherries

1 Using clear water, wet one cherry body with a no. 6 brush. Be sure to work on a flat surface to prevent puddling.

2 Apply Brown Ochre with a no. 4 brush to a wet paper surface (the amount of pigment will determine the strength of the color).

3 Repeat step 2 with Dark Carmine and Vermilion.

4 Leave the highlight free of color. Lightly dab around the highlight with a dry cotton swab.

5 Create secondary highlights at the sides of the cherry by lightly wiping with a cotton swab.

6 Air dry to prevent running.

7 Remove hard edges by lightly layering applicable color and wetting with a nearly dry no. 0 brush.

Stems

8 Wet the stem area with a no. 2 brush as in step 1.

9 Apply Van Dyke Brown with no. 2 brush as shown.

10 Repeat step 9 with Brown Ochre, Sap Green and Cream.

Shadows

11 Wet the shadow areas with a no. 4 brush.

12 Apply Medium Grey with a no. 4 brush.

13 Repeat step 12 with True Blue and Vermilion.

14 Clean up the edges by lightly layering applicable color(s) with a dry pencil and wetting with a small, nearly dry brush.

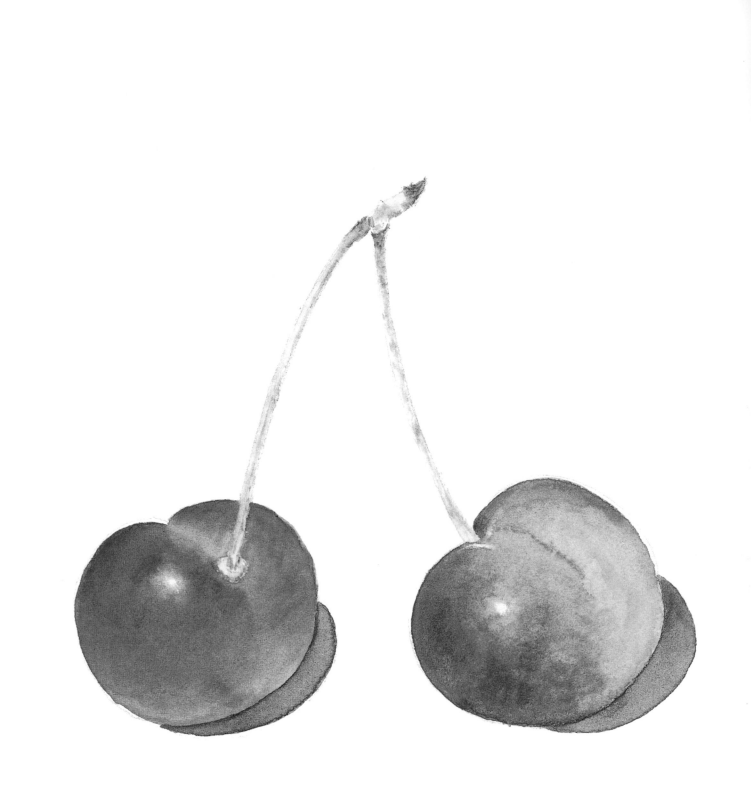

DRY-ON-WET TECHNIQUE

Apply dry water-soluble pencil on wet paper.

This technique will require some practice since it's necessary to apply a moderate amount of water to the paper, resulting in a lack of control over where the color goes. Of course, that's the whole idea of using this technique—to give a loose, impressionistic, watercolor look to your painting that shows obvious strokes.

After thoroughly wetting the paper surface, apply color. Use a round or flat point on the pencil to prevent damage to the paper. Strokes can be linear or circular, as shown in this example. Colors are applied in the same sequence as the other techniques, but you must work quickly while the paper surface is still wet. Use a dry cotton swab or small pieces of paper towel to absorb any areas that puddle.

Instead of worrying about leaving the paper free of pigment in the highlight areas, erase with an ink eraser strip in an electric eraser after the painted area dries.

PROCEDURE

The procedure is the same as Wet-on-Wet Technique 1, except as previously described. The palette of the cherry body is limited to Brown Ochre, Ochre, Scarlet Lake and Vermilion.

DRY-ON-DRY TECHNIQUE

Apply dry water-soluble pencil on dry paper.

For skeptics who are still convinced watercolors offer more versatility than water-soluble pencils, try this!

By applying dry pencil, using sharp points and circular strokes on a toothy watercolor paper surface, you can achieve a pointillist effect as shown here. This can be combined with other techniques to produce everything from tight realism to loose impressionism.

PROCEDURE

Cherries

1 Layer with Brown Ochre, Ochre, Dark Carmine, Scarlet Lake, Pale Geranium Lake, Vermilion and Dark Orange. Leave the highlight areas free of color.

Stems

2 Lightly layer with Van Dyke Brown and Brown Ochre. Lightly layer with Sap Green and Cream.

Shadows

3 Layer with Medium Grey, True Blue and Vermilion as shown.

VARIATION, WET-ON-DRY TECHNIQUE 1

Colors layered dry at the same time on dry paper, then wet with a cotton swab.

To achieve a rougher, looser look, try applying water to layered color with a cotton swab instead of a brush. The style can be changed by varying the amount of water absorbed by the swab. If just the tip of the cotton swab is quickly dipped in the water, it produces a dry, rough stroke with intense color saturation, because less pigment is dissolved when the color is applied. Conversely, if the cotton swab is saturated with water, it will produce a smoother "watery" look with paler colors.

PROCEDURE

Use the same procedure as with a brush (see pages 24-25), except a cotton swab is used.

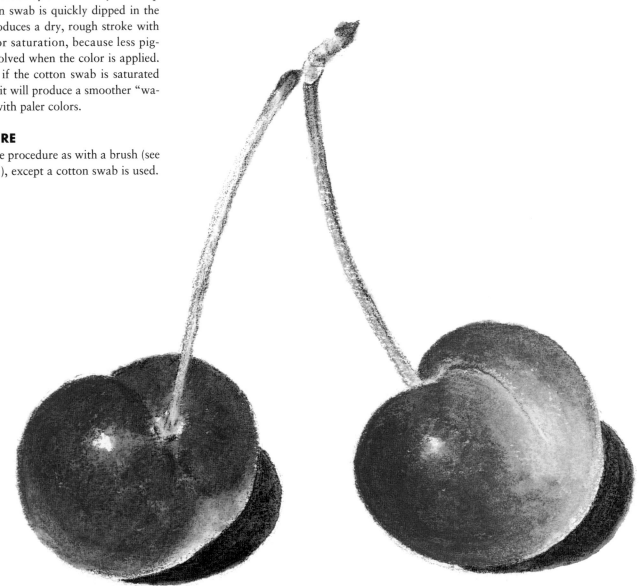

VARIATION, WET-ON-DRY TECHNIQUE 3

Apply color with a wet cotton swab onto dry paper.

To produce a distinctly impressionistic look, use a cotton swab to apply color instead of a brush. The style can be varied by adjusting the amount of water in the cotton swab. This illustration was created by using a minimal amount of water in the swabs. Use separate swabs for each color and gradually add pigment by dabbing or stroking until swab is dry, then discard. Colors can be blended or lightened by using a swab with clear water.

PROCEDURE

Use the same procedure as with a brush (see page 28), except a cotton swab is used.

Combining Water-Soluble Pencil Techniques

The water-soluble pencil techniques we've described can be combined. Here are just a few of the possibilities:

Combination 1
WET-ON-DRY 3 AND DRY-ON-DRY TECHNIQUES

In this demonstration the lighter colors (including their darkest values) were underpainted first with color on the brush. Then the stronger colors were layered on top with dry water-soluble pencil. Oil- or wax-based colored pencils can be used instead.

PROCEDURE

1 Apply Brown Ochre to the appropriate areas with a moderately wet no. 4 brush. Add a small amount of water to soften the edge and to graduate value.

2 After allowing the Brown Ochre to dry somewhat (but not completely), apply Ochre and Ochre + Dark Orange. Allow to dry.

3 Apply small amounts of highly diluted Sap Green, Van Dyke Brown, Brown Ochre and Cream in separate layers to stems with a no. 2 brush, as in steps 1 and 2. Allow to dry.

4 Apply Medium Grey to the shadows with a moderately wet no. 4 brush. Allow to dry.

5 Layer the cherry body with dry Dark Carmine, Scarlet Lake, Pale Geranium Lake, Vermilion and Dark Orange pencils. Leave the highlight areas free of color.

6 Layer the stems with dry Van Dyke Brown and Brown Ochre as shown.

7 Layer the shadows with dry Vermilion and True Blue pencils as shown.

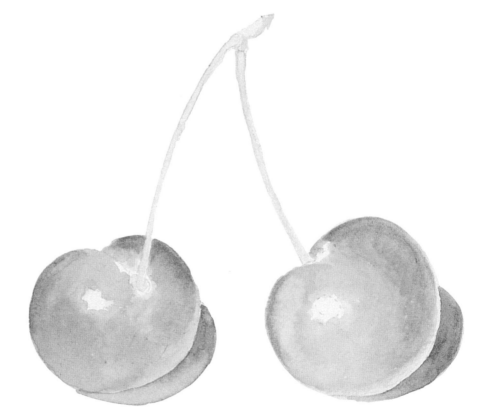

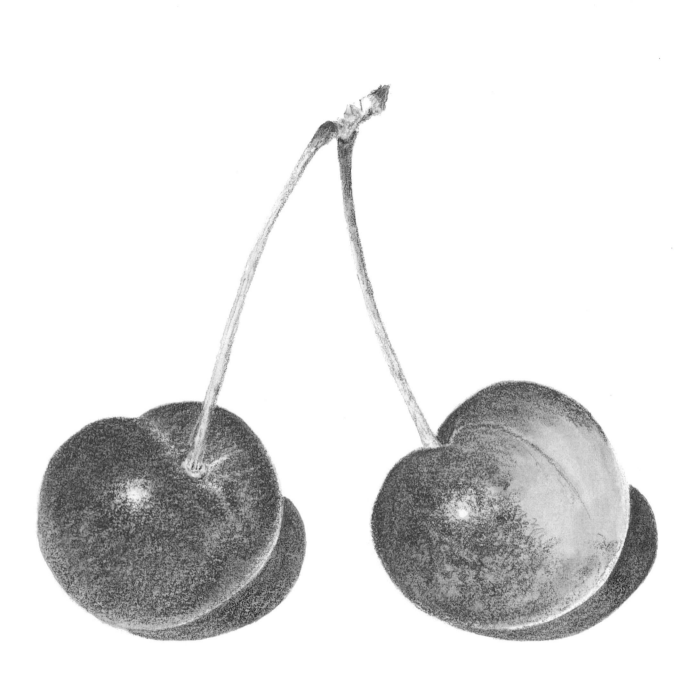

Combination 2
WET-ON-WET 2 AND DRY-ON-WET TECHNIQUES

This combination involves sketching or drawing lines with water-soluble pencil on the still-wet paper after color has been added with the brush. For a loose, impressionistic look, the paper can be dried after the color is added, rewet and then sketched with the dry pencil. In either case, use caution when using the dry pencil on the wet paper so you don't injure the surface. Vary the width of the pencil point by flattening it on a piece of sandpaper.

PROCEDURE

Follow step-by-step procedure described for Wet-on-Wet Technique 2 (see pages 30-31). While the paper is still wet, draw lines with the dry water-soluble pencil. Additional lines can be added by rewetting the paper.

Color Palette

Brown Ochre
Cream
Dark Carmine
Medium Grey
Ochre
Sap Green
True Blue
Van Dyke Brown
Vermilion

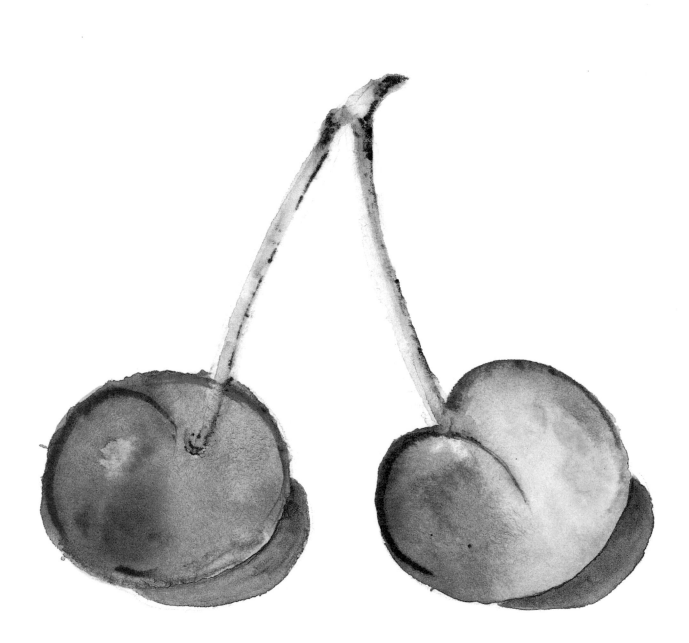

COMBINING WATER-SOLUBLE PENCILS WITH WAX- OR OIL-BASED COLORED PENCILS

Wet-on-dry and oil-based colored pencil with or without solvent.

Combining wax- or oil-based (dry) pencils with water-soluble colored pencils will add an entire new dimension to your artistic repertoire. Many colored pencil manufacturers have a parallel line of wax- or oil-based colored pencils matching their water-soluble line. The most notable exception is Sanford Prismacolor, which only produces wax pencils.

Wax- or oil-based colored pencils can be layered dry over areas underpainted with water-soluble pencils, or solvents like Turpenoid, mineral spirits and rubber cement thinner (Bestine) can be added without affecting the water-soluble layers. As demonstrated by this illustration, values of the weaker yellows and oranges were underpainted with water-soluble Lyra pencils first, then the stronger reds were layered on top with equivalent oil-based Lyra pencils. Bestine rubber cement thinner is then dabbed on, liquefying the oil-based layers. You might expect the water-soluble layers to be affected, but as you can see, they are not. There's more information about this technique in the books *Creating Textures in Colored Pencil* and *Creating Radiant Flowers in Colored Pencil*, both published by North Light Books.

PROCEDURE

Cherries

1 Layer with dry Brown Ochre, Dark Orange and Ochre water-soluble pencils. Leave the highlight areas free of color.

2 Apply water with a moderately wet no. 4 brush, starting with the lighter Ochre areas first. Leave the the highlights free of color. Drag lighter applications of color into the areas with secondary highlights. Dry with a hair dryer or allow it to air dry.

3 After the paper is completely dry, layer with Dark Carmine, Scarlet Lake, Pale Geranium Lake and Vermilion oil-based pencils.

4 Dab with Bestine using a no. 4 brush.

(Use an old or inexpensive brush when using solvent since it will cause your brushes to expire at an early age.)

Stem

5 Lightly layer Brown Ochre, Sap Green and Cream water-soluble pencils.

6 Apply water with a moist no. 2 brush. Dry with a hair dryer or allow the area to air dry.

7 After the paper is completely dry, layer with Van Dyke Brown and Brown Ochre oil-based pencils.

8 Apply Bestine with a no. 2 brush.

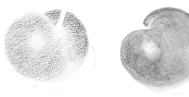

Shadows

9 Layer with Medium Grey water-soluble pencils.

10 Apply water with a moderately wet no. 4 brush. Dry with a hair dryer.

11 Layer True Blue and Vermilion oil-based pencils, as shown.

12 Apply Bestine with a no. 4 brush.

13 Layer with Medium Grey oil-based pencil.

14 Apply Bestine with a no. 4 brush.

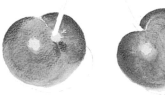

Color Palette

Pencils denoted (O) = Lyra Rembrandt Polycolor
(oil based)
 Pencils denoted (WS) = Lyra Rembrandt Aquarell
 Brown Ochre (WS and O)
 Cream (WS)
 Dark Carmine (O)
 Dark Orange (WS and O)
 Medium Grey (WS and O)
 Ochre (WS)
 Pale Geranium Lake (O)
 Sap Green (WS)
 Scarlet Lake (O)
 True Blue (WS and O)
 Van Dyke Brown (WS and O)
 Vermilion (O)

MASKING

This demonstration adds a background to our two lonely cherries by masking them with low-tack frisket, painting in the background and (after removing the frisket), completing the cherries.

Low-tack frisket should be used instead of sticker versions to prevent damaging the paper surface. Some bleeding may occur if the frisket is not properly pushed down or burnished, especially when painting wet washes on toothy paper. To keep bleeding to a minimum, burnish the frisket by first placing the frisket backing (or any paper) on top of the area to be burnished. This prevents impressing unwanted lines on the paper. Burnish large masked areas with a brayer, then use the flat end of a burnishing tool to burnish smaller areas, including the edge of the frisket where it meets unmasked paper.

Areas smaller than the width of the stems should be masked with liquid mask to prevent bleeding especially when painting on heavily textured paper.

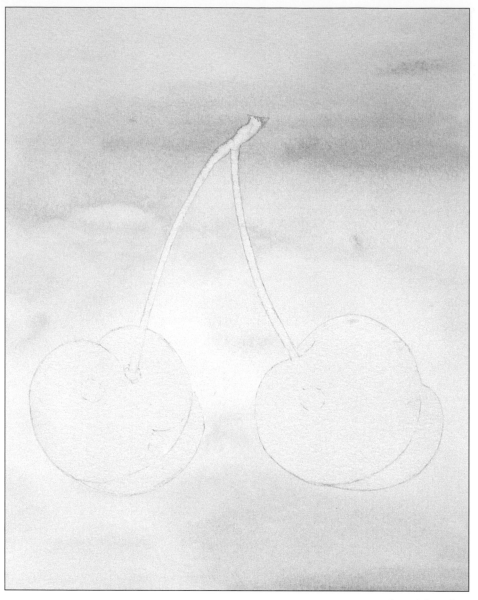

Steps 1 through 6

PROCEDURE

1 Lay out the painting as described on page 24.

2 Cut a piece of frisket paper approximately one inch larger all around than the area to be masked, in this case the cherries.

3 After removing the backing from the frisket, carefully place it over the area to be masked.

4 Press the frisket down with your hand and then burnish, placing the frisket backing (or any paper) between the brayer and the flat side of the burnishing tool.

5 Using a new no. 11 X-Acto knife blade, carefully cut along the edges to be masked. If you're using an X-Acto knife for the first time, it may be a good idea to practice on a separate piece of paper before trying a serious painting. It requires some skill to cut the frisket so it peels away without tearing or cutting deeply into the paper surface.

6 Carefully peel away the excess frisket.

7 Burnish again, placing backing between the flat end of the burnishing tool and the paper.

8 Wet the entire paper surface with clear water, using a no. 14 acrylic brush.

9 Apply Brown Ochre and Ochre with a no. 10 brush. Air dry.

10 Using a no. 16 X-Acto knife blade, carefully lift the frisket paper by placing the tip of the blade under the edge of the frisket and lifting up.

11 Complete the painting using the technique of your choice. The sample illustration used Wet-on-Dry Technique 3 (see page 28).

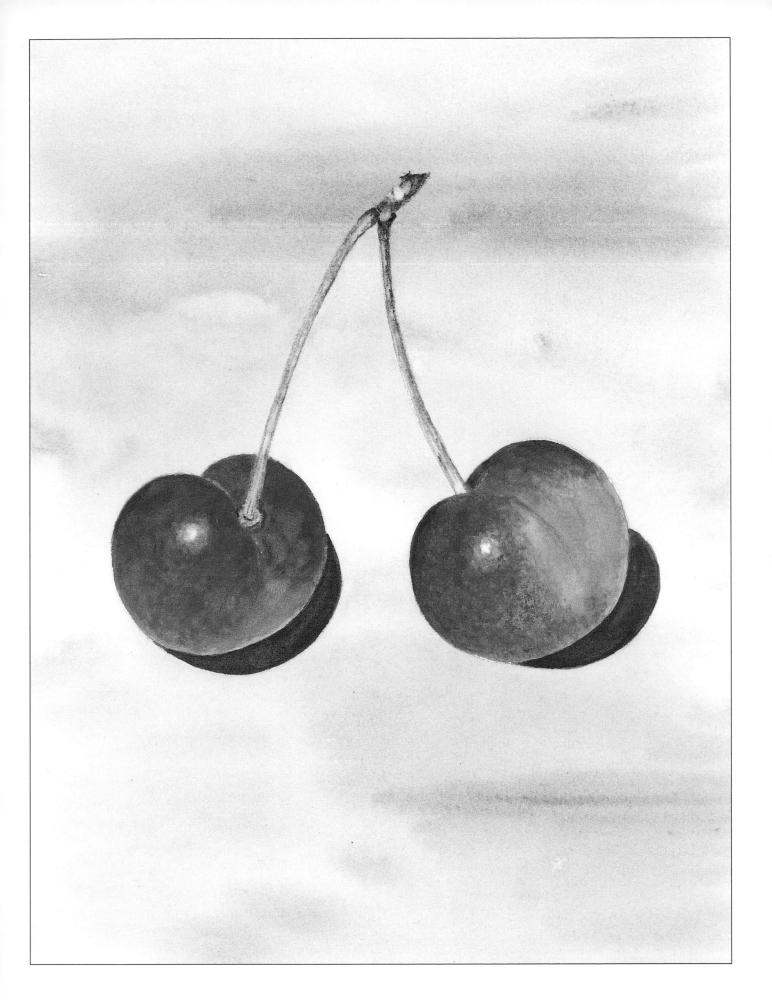

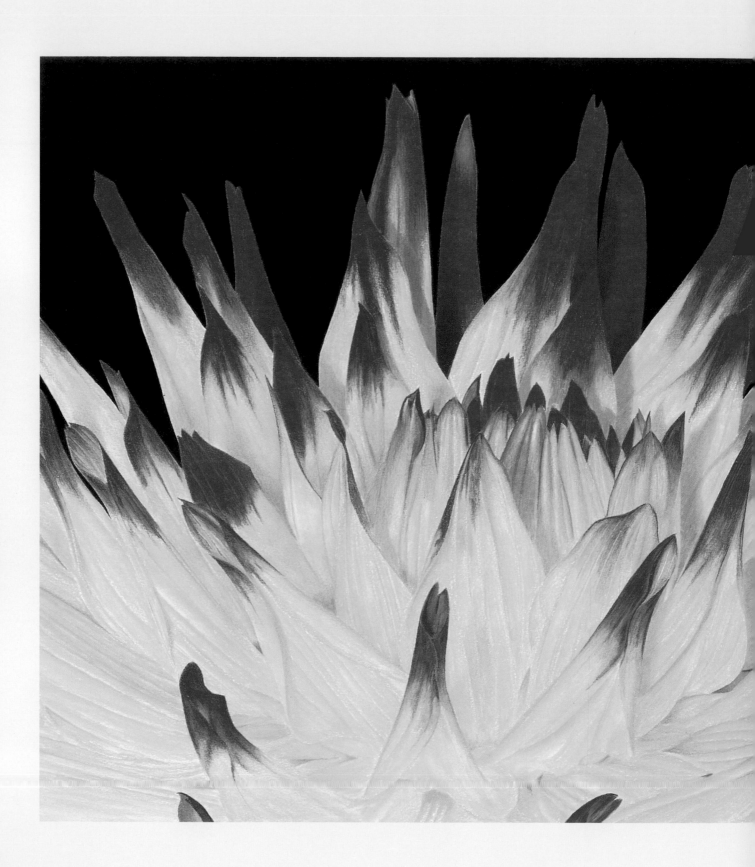

DEMONSTRATIONS

The following eighteen demonstrations span a wide range of styles, subjects, techniques and complexity, all painted in water-soluble colored pencil. Some defy the fact that they have been done with pencil, looking exactly like watercolor paintings. Others have the look of oil or acrylics, and still others look like everything in between. This is one of the many advantages of water-soluble colored pencil—its versatility.

These talented and creative contributors were selected not only for their obvious skills but also for their diversity in style. Floral, animal, portrait, still life, landscape, architectural and abstract subjects have been depicted using the techniques described, resulting in the widest possible range of water-soluble colored pencil art within the scope of this book.

Each of the demonstrations lists the brand and color of water-soluble colored pencil used, a materials list (omitting obvi-ous tools such as erasers, sharpeners, water containers, etc.), a description of how the art was laid out and a step-by-step process of how the art was done. The processes have been simplified to make these demonstrations accessible to as many artists as possible—no one would want to try these demos if every nuance was included. It's also not necessary to go out and buy every water-soluble colored pencil known to humankind to try out the techniques. Consult with the color charts on pages 14-17 and feel free to substitute.

Rather than copying the demonstration paintings, the paintings have been broken down into steps to show you how the process of water-soluble colored pencil painting works and to help you get started on your own paintings. Most of you will be trying this medium for the first time, so practice a little and give yourself some time. You'll be glad you did!

FLOWER POWER 3
Gary Greene
17" × 24" (43cm × 60cm)
Wet-on-Dry Technique 2 and Wax-Based Colored Pencil

Matchstix

by Gary Greene

WET-ON-DRY TECHNIQUE 1 AND DRY-ON-DRY TECHNIQUE

This "collection" of matches was created primarily by dry brushing color that was layered with a moistened brush.

MATERIALS

22″×30″ (55cm×75cm) 140-lb. (300gsm) Lanaquarelle cold-press watercolor paper

nos. 3, 4 and 6 round sable brushes

paper towels

LAYOUT

An original transparency was projected onto paper and was traced with a Derwent Silver-Grey water-soluble pencil.

Color Palette

FABER-CASTELL ALBRECHT DÜRER:
Cool Grey V, VI
Warm Grey IV, V

LYRA REMBRANDT AQUARELL:

Blue-Violet	Ochre
Dark Orange	Pale Geranium Lake
Dark Sepia	Sky Blue
Hooker's Green	True Blue
Indian Red	True Green
Light Orange	Vermilion

REXEL DERWENT WATERCOLOUR:

Brown Ochre	Raw Sienna
Burnt Yellow Ochre	Raw Umber
Flesh Pink	Silver-Grey
Golden Brown	

SANFORD VERITHIN:
Sienna Brown

Step 1: Paint the Wooden Matchsticks

Apply Faber-Castell Warm Grey IV or V and Derwent Raw Umber to the darkest shadow areas. Apply Derwent Raw Umber to lighter shadow areas.

Apply Derwent Raw Sienna, Flesh Pink and varying combinations of Derwent Brown Ochre, Golden Brown and Lyra Ochre for each stick. Apply water with moist no. 6 brush.

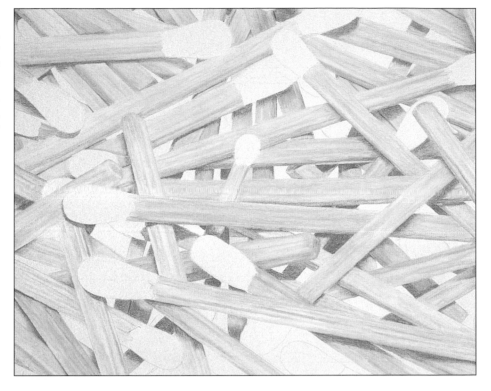

Step 2: Paint the Match Heads

Lightly layer the darkest values. Layer the lighter values, using less pigment in the highlight area.

To paint the red match heads, use a dark value of Lyra Indian Red and a light value of Lyra Pale Geranium Lake. To paint the light blue match heads, use a dark value of Faber-Castell Cold Grey V and/or Lyra Paris Blue and a light value of Lyra Sky Blue. To paint the dark blue match heads, use a dark value of Faber-Castell Cold Grey VI and a light value of Lyra True Blue and Blue-Violet. For the green match heads, select a dark value of Lyra Hooker's Green and a light value of True Green. To paint the orange match heads, use a dark value of Lyra Vermilion and/or Lyra Dark Orange, and a light value of Lyra Light Orange.

Apply water with a very dry no. 4 round brush in a circular stroke, leaving small spots of paper showing, particularly in the highlight area. Dry with a hair dryer. Re-layer the color dry over the painted area.

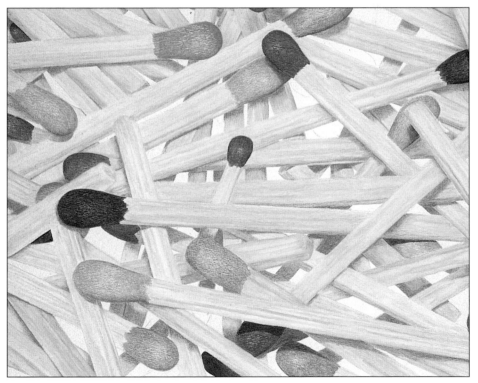

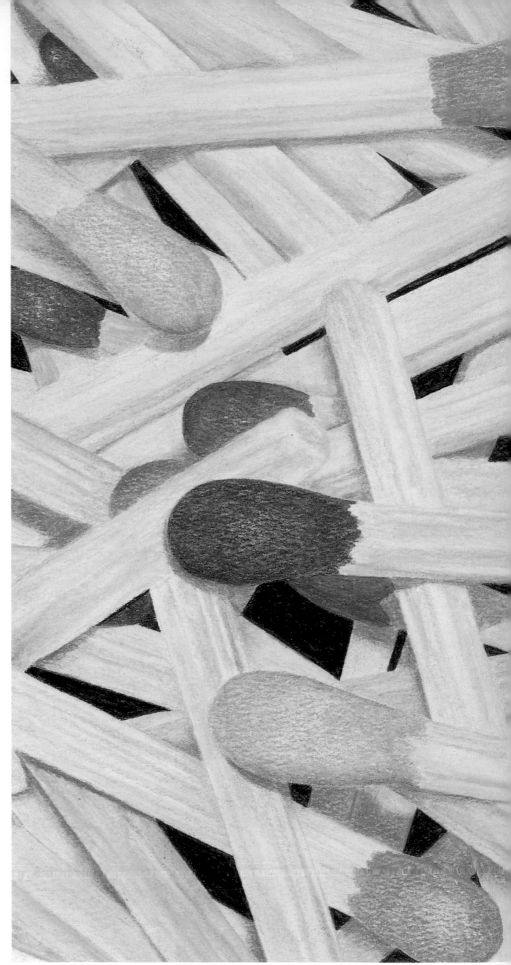

Step 3: Lay in the Background

Apply Lyra Dark Sepia to the remaining background areas. Apply water with a medium-wet no. 3 or no. 4 round brush. Allow this to dry and repeat as necessary. Sharpen the background edges with Sienna Brown Verithin.

MATCHSTIX
Gary Greene
10¼" × 14" (26cm × 35cm)
Wet-on-Dry Technique 1 and
Dry-on-Dry Technique

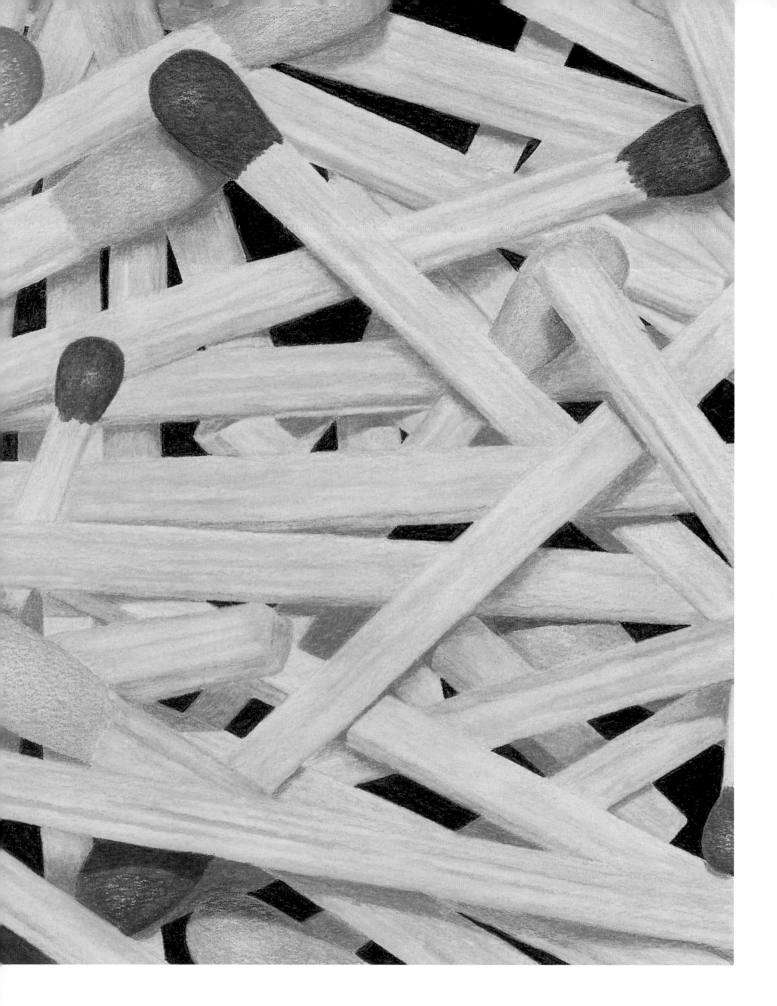

Seashells With Glass Floats

by Dyanne Locati

WET-ON-WET TECHNIQUE 1

This traditional still-life study was painted using a palette created by applying dry water-soluble colored pencil to a piece of museum board, then applying the pigment with a wet brush to the wet paper.

MATERIALS

140-lb. (300gsm) Lanaquarelle cold-press watercolor paper
no. 2 graphite pencil
four-ply Bainbridge museum board
household sponge
no. 1 flat brush
nos. 6 and 10 round brush

LAYOUT

Draw the subject lightly with a no. 2 graphite pencil on 140-lb. (300gsm) watercolor paper. Create a palette by applying dry 2″ swatches of each color to a four-ply museum board.

PAINTING

Color is applied by wetting the brush and picking up pigment from museum board palette and applying it to the painting. Wait until your paper is dry before replacing color on the museum board. Use a household sponge to control water in your brush.

Color Palette

FABER-CASTELL ALBRECHT DÜRER:		LYRA REMBRANDT AQUARELL:	
Azure Blue	Lemon Yellow	Apple Green	Olive Green
Blue-Green	Light Cobalt Blue	Brown Ochre	Pompeian Red
Brown Ochre	Light Phthalo Blue	Cool Light Grey	Raw Umber
Canary Yellow	Night Green	Gold Ochre	Van Dyke Brown
Cobalt Blue	Olive Green	Indian Red	Venetian Red
Delft Blue	Sanguine	Medium Grey	Viridian
Grass Green	True Green	Night Green	White
Hooker's Green	Zinc Yellow	Ochre	
Lemon Cadmium			

Step 1: Establish Shapes

Wet the shapes in back of the shell with a no. 1 flat brush. Apply Faber-Castell Azure Blue, Delft Blue, Hooker's Green and Night Green. Apply Lyra Night Green and Olive Green. Randomly apply color from the palette to the background shapes with a wet no. 10 round brush.

With a no. 1 flat brush, wet the shapes in the foreground. Apply the same colors used in background.

Step 2: Establish the Shell

Wet the inside shapes of the shell with a no. 1 flat brush. Drying between each color, apply glazes of Faber-Castell Azure Blue, Delft Blue, Canary Yellow, Hooker's Green, Lyra Night Green, Viridian, Gold Ochre, Indian Red and Pompeian Red from the palette. Holding the no. 1 flat brush upright, use the edge of the bristles to achieve sharp lines.

Apply Lyra Venetian Red, Indian Red, Faber-Castell Lemon Cadmium, Lemon Yellow and Zinc Yellow from the palette to the right side of the shell. Apply Faber-Castell Grass Green, Hooker's Green, True Green, Light Cobalt Blue and Light Phthalo Blue to the left side. If the surface dries, add water.

Wet the bottom half of the shell. Dip a Lyra Raw Umber pencil with a sharp point into the water and draw texture lines on the shell. Using cool colors in concave areas and warm colors in convex areas, apply Lyra Brown Ochre, Cool Light Grey, Medium Grey, Ochre, Olive Green, Raw Umber and Van Dyke Brown from the palette to depict the shell's rough texture. Leave some lines free of color. Soften the textured lines with a wet no. 6 round brush.

Dip Lyra White and Cool Light Grey pencils in clear water for five seconds. Roll the side of the wet pencils on the wet textured area of the shell. Roll over the texture lines in the bottom of the shell. Apply Lyra Apple Green from the palette to depict highlights.

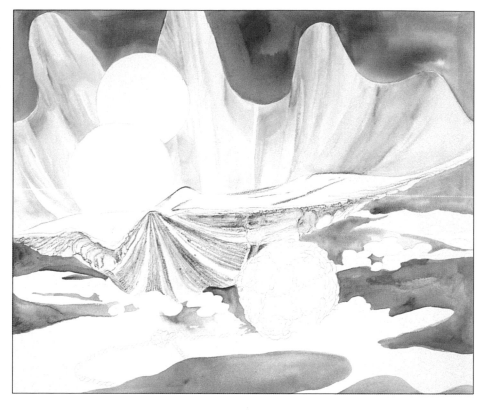

Step 3: Establish Glass Floats Inside the Shell

Place color on a four-ply museum board (use the same color and paper museum board palette as in step 1.) Wet the area in the top glass float with a no. 10 round brush. Apply the same colors as in step 1 from the museum board with a wet no. 6 round brush. Use the colors seen from the background on the glass float. One side of the glass float is warm and light, the other side is cool and dark.

Lift the highlights on the glass with a no. 6 round brush. Wet the area, place the brush in water, touch a household sponge to control water and brush the area to lift the color.

Start the foreground shapes by drawing in the pebble and sand field area. Draw the negative shape and leave the pebble shape light. Wet the area with a no. 10 round brush. Apply Lyra Brown Ochre, Olive Green and Raw Umber pencils by dipping the pencil points in water and drawing the shapes.

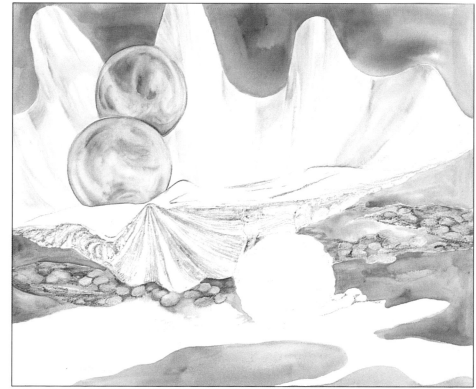

Step 4: Establish a Glass Float With the Rope

Wet the areas on the glass ball with a no. 10 flat brush, leaving the rope dry. Apply Faber-Castell Brown Ochre, Olive Green, Sanguine, and Lyra Raw Umber from the palette with a no. 6 round brush. Leave some areas light for highlights and reflections.

Apply Faber-Castell Blue-Green and Lyra Apple Green from the palette to the rope around the back of the glass float with a no. 6 round brush.

Apply Faber-Castell Cobalt Blue, Canary Yellow, Blue-Green, and Lyra Apple Green from the palette to the rope in front of glass float with a no. 6 round brush. Repeat as necessary.

Draw a small cord beside the glass float with Faber-Castell Blue-Green, Cobalt Blue, True Green, Zinc Yellow, and Lyra Medium Grey. Use light colors on top of the rope. Wet a no. 6 round brush lightly and go over the small cord. Adjust the color by adding water in some areas to lighten; add more color in dark areas.

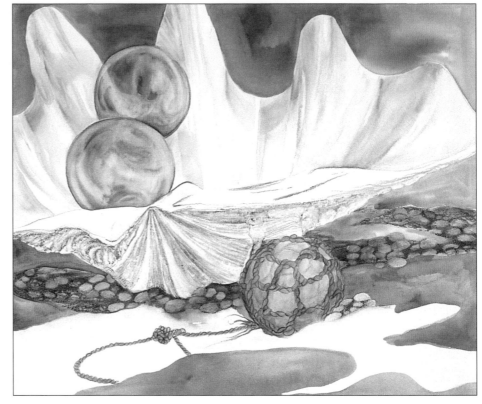

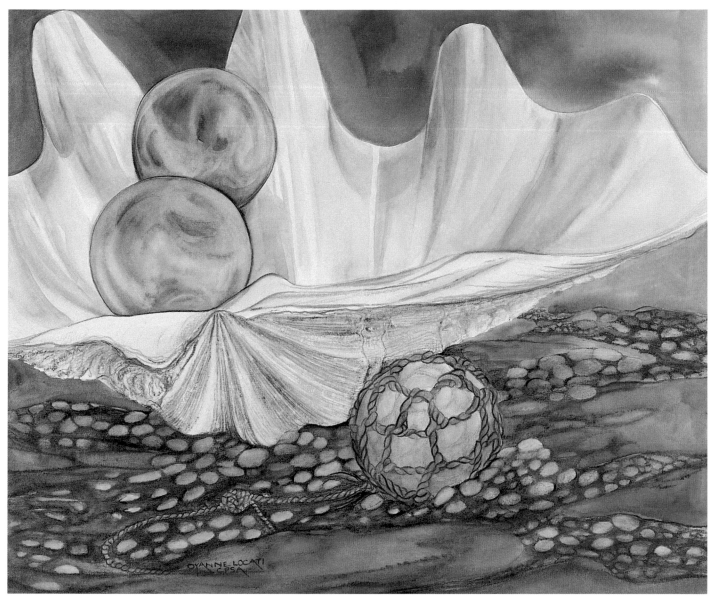

Step 5: Establish Pebbles

Draw negative shapes around the pebbles with Lyra Brown Ochre, Medium Grey, Night Green, Olive Green, Van Dyke Brown and Venetian Red; and Faber-Castell Brown Ochre, Canary Yellow, Delft Blue and Light Phthalo Blue. Wet a no. 6 round brush to soften areas around pebbles.

Place positive pebble shapes in random patterns and colors. Wet the area desired. Draw the pebbles with a wet colored pencil. Repeat as needed.

Paint around the pebbles with Lyra Van Dyke Brown and other dark colors until the desired look is achieved.

SEASHELLS WITH GLASS FLOATS
Dyanne Locati
13½" × 18" (34cm × 46cm)
Wet-on-Wet Technique 1

A Box of Clocks

by Bonnie Auten

WET-ON-DRY TECHNIQUE 1 AND COLORED PENCIL WITH SOLVENT

Bonnie's painting combines the most familiar water-soluble colored pencil techniques. The result is a complex, highly realistic painting that's most informative in the use of both water-soluble and dry colored pencil techniques.

MATERIALS

11″ × 14″ (27.9cm × 35.6cm) Windberg Light Gray multimedia panel
electric eraser
erasing shield
nos. 2, 4 and 9 round filbert brushes
½-inch (1.3cm) flat watercolor brush
Turpenoid solvent solution
Lyra Splender pencil

LAYOUT

The photo was projected onto a Windberg panel using a Verithin Medium Grey pencil. The picture was next redrawn, laying in the details using a Verithin Black pencil.

Color Palette

BRUYNZEEL DESIGN AQUAREL:
Black
Bruynzeel Green
Cerulean Blue
Cobalt Blue
Dark Grey
Light Grey
Light Vermilion
Prussian Blue
Sienna
Sky Blue
Turquoise Blue
Ultramarine
Umber
Vermilion
White

BRUYNZEEL FULLCOLOR:
Ash Grey
Brown-Grey
Bruynzeel Green
Cold Grey
Dark Brown-Grey
Dark Orange
Deep Warm Grey
Ivory Black
Kingfisher Blue
Light Cold Grey
Middle Brown
Pale Brown-Grey
Payne's Grey
Permanent Orange
Sepia
Yellow-Green

CARAN D'ACHE PABLO:
Mahogany
Prussian Blue

FABER-CASTELL ALBRECHT DÜRER:
Bister

FABER-CASTELL POLYCHROMOS:
Ivory
Light Ultramarine
Scarlet Lake
Van Dyke Brown
Warm Grey II
Zinc Yellow

LYRA REMBRANDT AQUARELL:
Canary Yellow
Gold Ochre
Ochre

LYRA REMBRANDT POLYCOLOR:
Brown Ochre
Cobalt Blue
Dark Orange
Light Cobalt Blue
Light Ochre
Ochre
Orange-Yellow
Raw Umber
Sepia
True Green

REXEL DERWENT STUDIO:
Deep Cadmium
Primrose Yellow

SANFORD PRISMACOLOR:
Beige
Black
Celedon Green
Cool Grey 50%
Cool Grey 90%
Dark Green
Dark Umber
French Grey 20%
Goldenrod
Indigo Blue
Sienna Brown
Metallic Copper
Metallic Gold
Pale Vermilion
Peacock Blue
Sand
Sienna Brown
Warm Grey 70%
Warm Grey 90%
White
Yellow Ochre
Yellowed Orange

SANFORD VERITHIN:
Black
Brown
Green
Medium Grey
Metallic Gold
White

Step 1: Establish Values

Establish a value scale using Bruynzeel Aquarel Black and White. Blend the areas with a no. 4 round brush.

Step 2: Begin Painting

Beginning with the yellow clock, apply Lyra Aquarell Gold Ochre, Ochre and Canary Yellow. Blend with a wet no. 4 round brush. Dry thoroughly. Apply Bruynzeel Aquarel Umber, Dark Gray and Sienna. Blend with a wet no. 4 brush.

Apply the red bells with Bruynzeel Aquarel Vermilion and Light Vermilion. Blend with a wet no. 4 round brush, leaving small areas blank for reflections. Apply the blue bells with Bruynzeel Aquarel Ultramarine and Cerulean Blue. Blend with a wet no. 4 round brush. Dry thoroughly. Apply Bruynzeel Aquarel Prussian Blue. Apply the lower bell with Bruynzeel Green and Sky Blue. Blend with a wet no. 4 round brush. Allow to dry.

Apply the upper clock face with Bruynzeel Aquarel Turquoise Blue and Cobalt Blue. Reapply Bruynzeel Aquarel White to the numbers and dots on the clock face. Blend with a moist no. 4 round brush.

Apply the copper bells with a Faber-Castell Aquarel Bister flat ½-inch (1.3cm) watercolor brush. Using a no. 2 round brush, add smaller details.

Apply the red area of the clock face with Bruynzeel Aquarel Light Vermilion. Blend with a wet no. 4 round brush. Dry thoroughly. Apply the outside dark circle with Bruynzeel Sienna. Apply a gray wash by crumbling the point of a Bruynzeel Aquarel Light Grey pencil and adding water. Apply the wash to the face of the clock with a ½-inch flat brush. Apply three separate layers and allow each to dry. This adds depth and shadow to the clock face. Before going on to next step, be certain the board is completely dry.

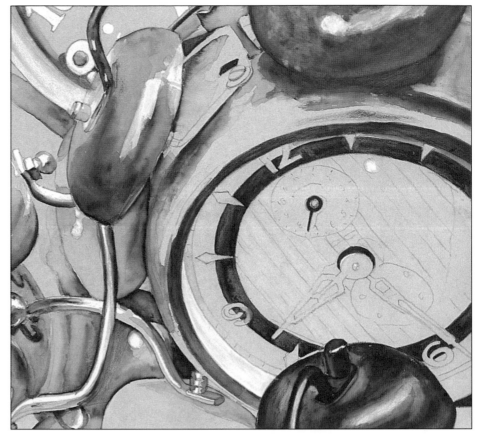

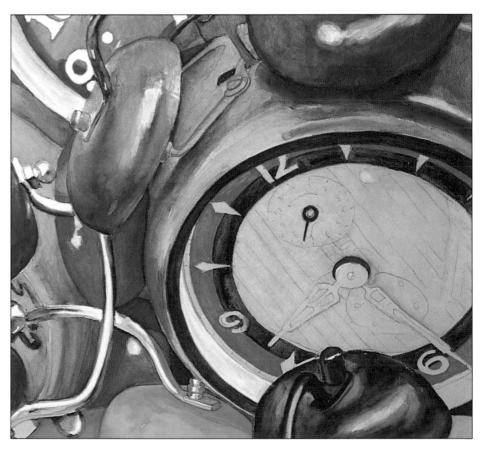

Step 3: Apply Dry Colored Pencil

All the pencils used in step 3 are dry colored pencils. Layer the yellow clock with Prismacolor Yellow Ochre and Goldenrod, Lyra Ochre and Orange-Yellow, Bruynzeel Sepia and Polychromos Van Dyke Brown.

Layer the deep shadows of the far-left blue bells with Prismacolor Black and Indigo Blue. Layer Pablo Prussian Blue, Bruynzeel Kingfisher Blue and Lyra Light Cobalt Blue. Burnish with Prismacolor White; reapply colors.

Layer gray on the shadowed face of the yellow clock with Prismacolor Black, Indigo Blue, Cool Grey 90% and Bruynzeel Brown-Grey. Layer lighter areas with Bruynzeel Light Cold Grey and Prismacolor Cool Grey 50%. Burnish with Prismacolor White; reapply colors.

Layer the white clock face with Prismacolor White over numbers and dots. Layer Prismacolor Indigo Blue, Pablo Prussian Blue and Lyra Cobalt Blue in the dark areas and Prismacolor Peacock Blue and Bruynzeel Kingfisher Blue in the light areas. Burnish with White; reapply colors. Layer Peacock Blue over the white numbers.

Layer the entire cool green bell with Lyra True Green. Layer Prismacolor Black, Dark Green and Indigo Blue in the shadows. Layer the lighter areas with Bruynzeel Green and Yellow-Green, and layer the lighter shadows with Bruynzeel Brown-Grey. Burnish with Prismacolor White; reapply colors.

Recontour the black bell with an electric eraser and an erasing shield. Layer the darkest areas with Prismacolor Black, Indigo Blue, Warm Grey 90% and Warm Grey 70%. Layer the lighter areas with Prismacolor French Grey 20% and White. Layer the midtone area with Bruynzeel Cold Grey and Pablo Prussian Blue. Layer the light areas with Polychromos Light Ultramarine. Reapply grays.

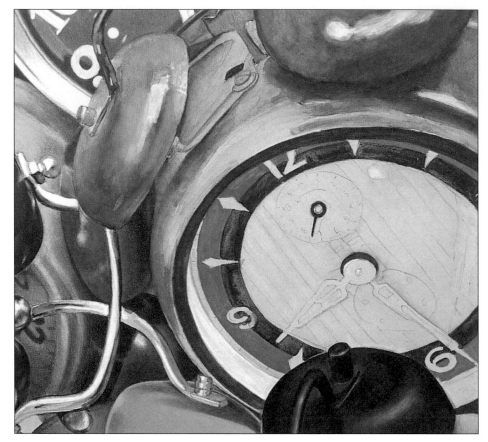

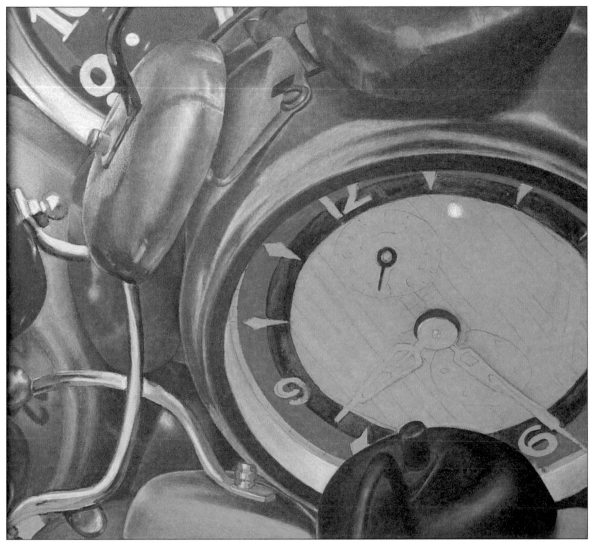

Step 4: Paint the Large Brass Clock

All the pencils used in step 4 are dry colored pencils. Layer the entire large brass clock with Lyra Raw Umber. Layer the dark areas with Lyra Sepia. Layer the entire area with Pablo Mahogany, Bruynzeel Dark Orange, and Prismacolor Yellow Ochre and Metallic Copper. Blend with Turpenoid solvent and a no. 9 round filbert brush. Reapply colors. Burnish with a Lyra Splender pencil. Reapply colors.

Layer inside the white rim with Bruynzeel Ash Grey, Dark Brown-Grey and Brown-Grey. Highlight with Prismacolor White and Prismacolor Beige.

Step 5: Paint Toward Completion

All the pencils used in step 5 are dry colored pencils. Redraw large clock face details with Brown Verithin. Trace over the brown lines with Prismacolor Metallic Gold, Lyra Light Ochre and Derwent Primrose Yellow.

Layer the entire clock face with Bruynzeel Dark Brown-Grey, Pale Brown-Grey and Deep Warm Grey. Burnish the face with Prismacolor Beige and reestablish the lines with Lyra Brown Ochre. Reapply the colors. Burnish again with Lyra Splender. Layer the light reflection with Polychromos Ivory and Warm Grey II. Layer the yellow reflective areas with Prismacolor Yellow Ochre and Yellowed Orange, and Derwent Deep Cadmium.

Layer the dial hands with Prismacolor Metallic Gold, Sienna Brown, White, Celedon Green and Dark Umber. Draw the details with Verithin Metallic Gold, Brown, White and Green. Layer the metal with Bruynzeel Middle Brown and Permanent Orange. Layer the reflections with Lyra Light Ochre and Dark Orange. Darken the black center by layering Prismacolor Black and Dark Umber.

Layer around the black ring with Bruynzeel Ivory Black. Apply Turpenoid with a no. 2 round brush. Allow to dry. Sharpen the details with Verithin Black. Layer over the ring with Prismacolor Dark Umber and Bruynzeel Ivory Black.

Layer the red circle with Polychromos Scarlet Lake. Lightly apply Turpenoid with a no. 2 round brush. Allow to dry. Layer the circle with Bruynzeel Permanent Orange, and Prismacolor Pale Vermilion and Sand.

Layer the silver handles with Bruynzeel Ivory Black, Ash Grey, Payne's Grey and Prismacolor Cool Grey 50%. Lightly burnish the reflections with Polychromos Light Ultramarine, Zinc Yellow and Scarlet Lake. Burnish with Prismacolor White. Reapply color.

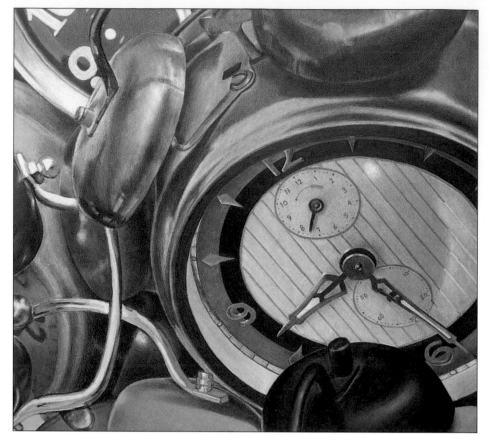

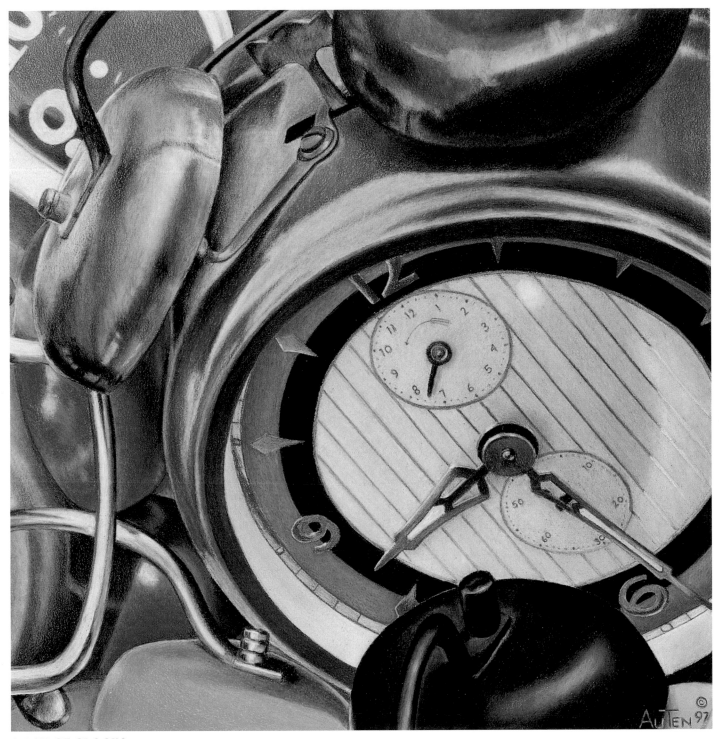

A BOX OF CLOCKS
Bonnie Auten
9½″ × 10¼″ (24cm × 26cm)
Wet-on-Dry Technique 1 and Colored Pencil with Solvent

Columbia's Cache

by Pat Averill

WET-ON-DRY TECHNIQUE 3

Pat's soft, understated landscape was painted by taking the colored pencil pigment from the lead and applying it to dry paper, known as the dry-brush technique in watercolor painting.

MATERIALS

- no. 6 round watercolor brush
- 300-lb. (640gsm) Lanaquarelle cold-pressed watercolor paper
- paper towels
- watercolor palette

LAYOUT

Place a small mark in the center of the paper and on the center of each side. Centers become static areas and are best avoided.

This landscape consists of hills in the distance, distant trees, closer trees and a foreground in shadow (from hills behind the viewer). Using a short dash, mark the largest area in shadow first since it takes up more than half the page. Notice the varied height of each horizontal area in the picture. Now mark where the remaining horizontal areas intersect the sides.

Color was applied by breaking the points off of pencils, putting them into a plastic palette and using them like cake watercolors or watercolor squeezed from a tube.

Color Palette

FABER-CASTELL
ALBRECHT DÜRER:
- Azure Blue
- Cream
- Dark Phthalo Blue
- Dark Sepia
- Delft Blue
- Fuchsia
- Light Flesh
- Light Phthalo Blue
- Sanguine
- Scarlet Lake

LYRA REMBRANDT
AQUARELL:
- Gold Ochre
- Night Green
- Olive Green

REXEL DERWENT
WATERCOLOUR:
- Blue-Grey
- Burnt Carmine
- Sky Blue

Step 1: Paint the Sky, Background Hills and Trees

Apply Derwent Sky Blue heavily to the top and right sides of the sky with a wet brush. Add a small amount of water to soften the pigment and graduate the value almost down to the horizon line.

Apply Faber-Castell Cream and Light Flesh with plenty of water at the horizon line to create distance. Use more water to make a smooth transition between the darker sky above and the lighter sky at the horizon. Allow to dry.

Apply Light Flesh to lightly mark the placement of the hills against the horizon. Apply a band of Derwent Blue-Grey for the hills. Before drying, use a clean, wet brush to pull out color where the sun hits the hills. Repeat the procedure in the lightest areas. Blot or wipe the brush on a clean paper towel before each application.

Apply a light wash of Faber-Castell Fuchsia under the rocks and where the sun hits the hills, using short vertical strokes. Apply a small amount of Lyra Olive Green for trees. Pull out the areas for the dark, distant trees with a clean, wet brush. Wipe the brush on a paper towel.

Apply concentrated Olive Green to the shadow side of the dark, distant trees by bouncing or patting the brush on paper. Apply Fuchsia to some shadowed sides. Lightly apply Faber-Castell Sanguine on the sunlit side of the darkest trees.

Block in the abstract shape of distant light-colored trees with Sanguine and Fuchsia. Apply Faber-Castell Light Phthalo Blue to the shadow areas on the left, on the tree bases and on the shadow areas of some trees that lie behind others. With a clean, wet brush pull out the light areas that give the trees shape.

Apply Lyra Gold Ochre with a wet brush. Apply a horizontal band of color for the sunlit grass. Dry with a hair dryer. With a fairly dry brush, apply Olive Green and Fuchsia to the dark areas beneath the trees and the base of some trees. Pull out the color with a clean, wet brush where the middle trees will be placed.

Step 2: Paint the Middle Trees and Water

Apply Olive Green with a small amount of water. Pat the brush on the shadow areas of the middle trees. To add depth, apply dabs of Fuchsia and Sanguine on the sides of the trees facing the sun. Apply Olive Green and Derwent Burnt Carmine in shadows under trees. Dry with a hair dryer.

Carefully apply concentrated Faber-Castell Dark Sepia and Burnt Carmine with the tip of the brush to the short tree trunks under the foreground trees. Allow to dry. Pull out some holes between the trunks with a clean, wet brush.

Apply Fuchsia to the grassy areas near the shadowed foreground edge with a very wet brush and a few horizontal strokes.

Apply Sky Blue at the top of the water with both vertical and horizontal brush-strokes, then apply Faber-Castell Light Phthalo Blue, Dark Phthalo Blue, Azure Blue and Delft Blue, graduating the colors from light to dark as they go down the page. Spread and thin with clear water to blend colors into one. Allow to dry.

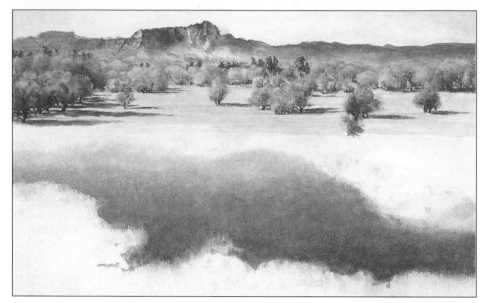

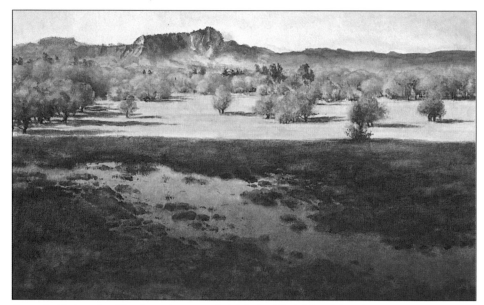

Step 3: Paint the Shadow Area and Add the Finishing Touches

Apply Delft Blue and Lyra Night Green to the darkest areas directly around water, varying the edges. While the pigment is still wet, apply Faber-Castell Dark Sepia in the remaining shadow areas and rocks by wetting broken pencil points and letting them stand for about twenty minutes, then applying the dissolved pigment.

Apply Gold Ochre to highlight the rocks and some grassy areas in shadow. Allow to dry thoroughly. It may be necessary to apply a small amount of Light Phthalo Blue under the background hills. Apply Faber-Castell Scarlet Lake to the left (sunlit) side of the tree trunks with a fairly dry brush. Wet the excessively dark areas and blot with a paper towel to lift the color and create texture. Apply Dark Sepia to add more depth in the rocks.

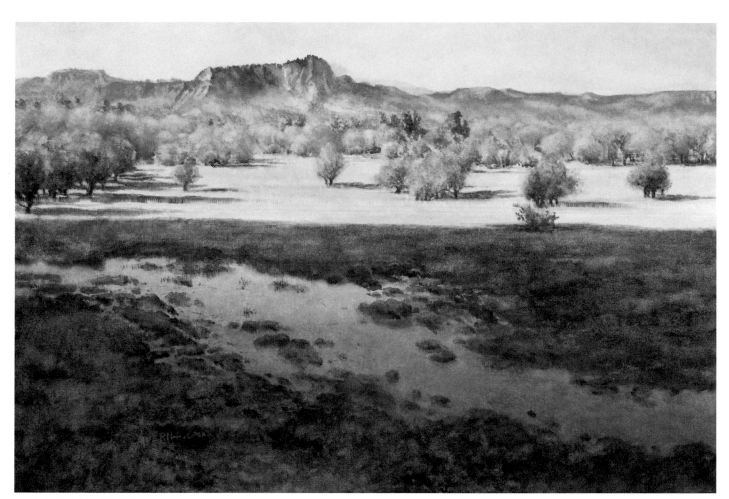

COLUMBIA'S CACHE
Pat Averill
8″×12″ (20cm×30cm)
Wet-on-Dry Technique 3

Venice Skyline
by Bernard Poulin
WET-ON-DRY 1 AND DRY-ON-DRY TECHNIQUES

Bernard's simple, eye-catching cityscape was painted on a colored paper surface with dry water-soluble colored pencil and wax-based Prismacolor pencil. When washed with water, the wax-based pencil created a resist.

MATERIALS

Tawny Grey acid-free mat board
no. 20 flat sable watercolor brush

LAYOUT

The silhouette of the Venice skyline was sketched using Faber-Castell Indigo Blue.

Color Palette

FABER-CASTELL ALBRECHT DÜRER:	REXEL DERWENT WATERCOLOUR:
Black	Spectrum Blue
Canary Yellow	
Dark Violet	SANFORD
Gold Ochre	PRISMACOLOR:
Indigo Blue	White
Light Carmine	
Night Green	
Wine Red	

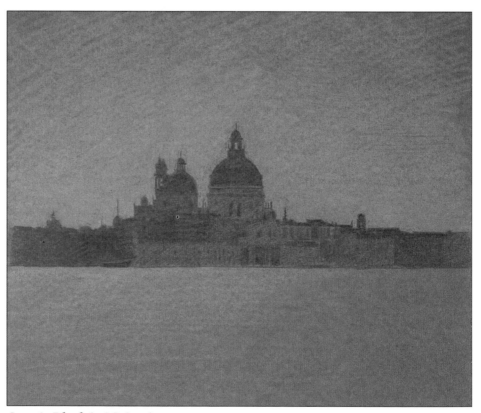

Step 1: Block in Major Areas

Fill in the skyline with Faber-Castell Indigo Blue, keeping the details as simple as possible. Fill in the sky with Faber-Castell Gold Ochre, using a rough crosshatching laid down heavily at the skyline and lighter as it edges toward the top of the painting.

Apply a lighter application of Gold Ochre beneath the skyline, more intense at the base of the skyline and gradually less gold as it edges toward the bottom of the painting.

Step 2: Wash the Painting

Using long, horizontal strokes, wash over the Indigo Blue skyline with a no. 20 brush. Rinse the brush thoroughly. Repeat the process over the gold sky and the tawny surface color of the sea.

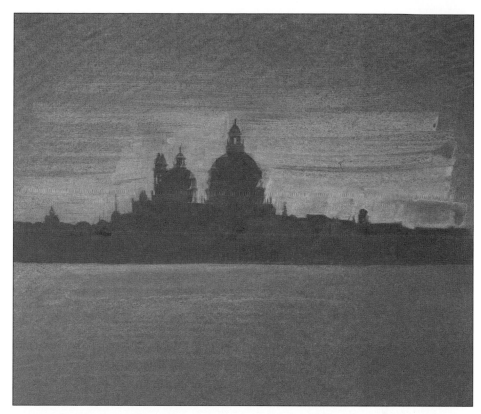

Step 3: Intensify the Sky and Details

Reapply Gold Ochre, crosshatching with alternating applications of Faber-Castell Canary Yellow. Repeat to intensify the sky. Blend the colors with a wet brush after each layer of color. Apply Faber-Castell Night Green for sketchy details in the dark blue skyline.

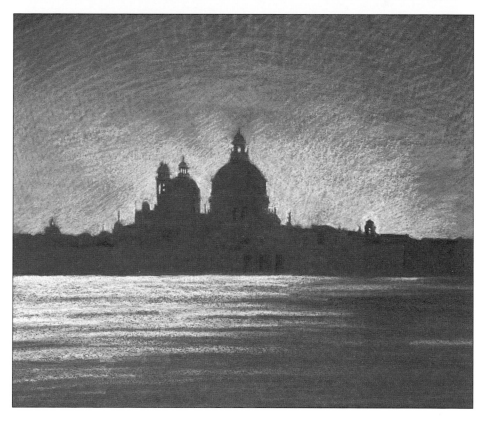

Step 4: Finishing the Details

Crosshatch cloud effects at the top of the painting with Faber-Castell Dark Violet, blending the Dark Violet into the brightness of the Gold Ochre.

The following applications are detail elements–don't overwork. Intensify the dark clouds by reapplying Dark Violet over a layer of Faber-Castell Light Carmine. With a no. 20 brush, wash the clouds with water to blend the pigment for a softened effect. Whenever the sky is touched, the same color should be added subtly to the water area. Retouch the skyline with Faber-Castell Night Green, Wine Red and Black, indicating the windows, arches and various other dark sections.

Add silvery horizontal stretches of highlights to the waterway with Prismacolor White. Wash the water with a no. 20 brush. When the various colors in the water are wet, the wax-based white "resists" the water. Reapply Night Green and wash to the skyline to reassert the desired moodiness.

Apply Faber-Castell Black and a small amount of Faber-Castell Wine Red to strengthen the presence of the sailboat to the left of the main structure. Apply long, horizontal strokes of Prismacolor White and Faber-Castell Canary Yellow to intensify the water's sparkling whiteness. To complete the scene, apply Derwent Spectrum Blue to depict soft, smoky clusters of mist over the skyline.

Apply a final wash, beginning with wet, horizontal strokes at the bottom of the painting surface and finishing at the base of the skyline with an almost dry brush.

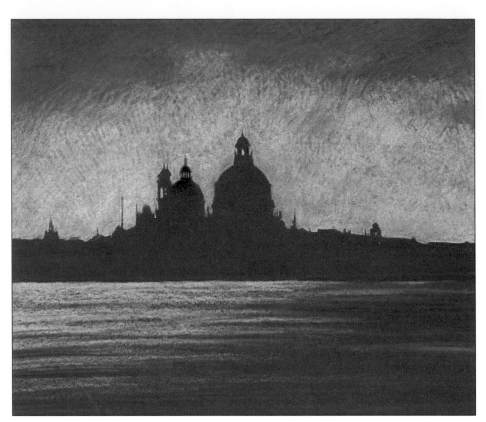

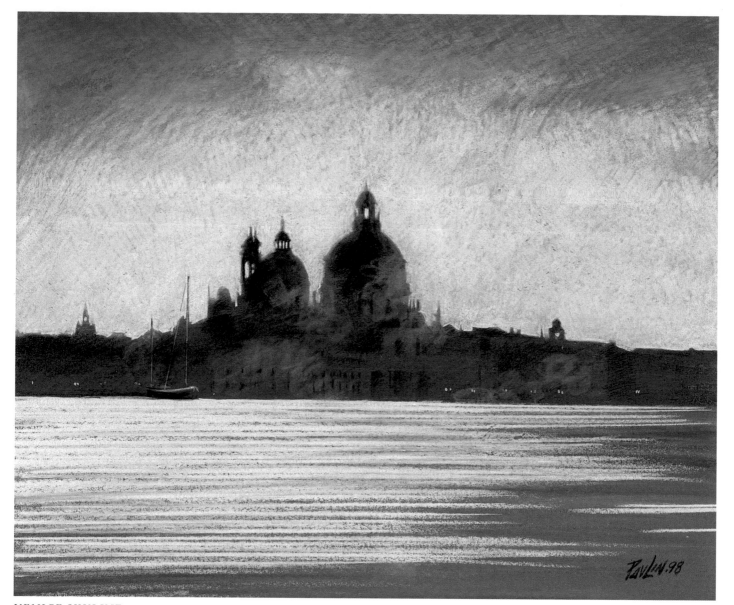

VENICE SKYLINE
Bernard Poulin
9″×12″ (23cm×30cm)
Wet-on-Dry 1 and Dry-on-Dry Techniques

Pueblo Gem
by Pat Averill
WET-ON-DRY TECHNIQUE 1

Pat has captured the essence of the Southwest in the subtle textures and colors of this architectural study, created by applying water to many layers of water-soluble colored pencil.

MATERIALS

- 300-lb. (640gsm) Lanaquarelle cold-press watercolor paper
- nos. 6 and 12 round watercolor brushes
- reusable adhesive
- clear ruler
- paper towels (to blot excess pigment and water)

LAYOUT

Draw borders with Derwent Sky Blue. Place a dot in the center and on the center of each border. Outline dark shapes with Pink Madder. With the reference photo parallel to the borders of the drawing, use a clear plastic ruler to plot the correct angles of the buildings. Hold the ruler even with the top edge of the dark building. Carefully slide the ruler down, keeping the same angle, and plot it on the drawing. Repeat with each angle. Complete the basic outline drawing. Use reusable adhesive for corrections.

Color Palette

FABER-CASTELL ALBRECHT DÜRFR:	LYRA REMBRANDT AQUARELL:	REXEL DERWENT WATERCOLOUR:
Azure Blue	Blue-Violet	Burnt Carmine
Blue-Green	Brown Ochre	Blue-Grey
Cold Grey III	Burnt Ochre	Dark Violet
Fuchsia	Dark Sepia	Madder Carmine
Light Cobalt Blue	Rose Carmine	Sky Blue
Orange-Yellow		
Tangerine		

Step 1: Paint the Sky

Lightly apply Derwent Sky Blue with a sharp pencil. Leave the paper white where the clouds will be. Wet a no. 6 round brush liberally, then tap it on a folded paper towel. Start just inside the cloud area and work into the blue sky. Dry with hair dryer. Add more Sky Blue to the top left and right areas if needed, wetting in the same manner as before.

Step 2: Paint the Background Hills and Dark Areas of Buildings

Lightly apply Faber-Castell Blue-Green with a sharp pencil to the background hills. Remove some of the color in the distant hills with reusable adhesive. Fill in with a light application of Faber-Castell Fuchsia, combining it with the Blue-Green.

Wet the background hills with a clean, wet, blotted no. 6 brush. Dry with a hair dryer. Rewet the areas with too much color with a clean brush and blot the excess color off with a paper towel. Dry with a hair dryer.

Outline the dark chimneys with Lyra Dark Sepia. Apply Dark Sepia with medium pressure. Color in the remaining darkest darks first, using a sharp pencil and heavy pressure. Then color in the medium darks with a rounded tip and medium pressure.

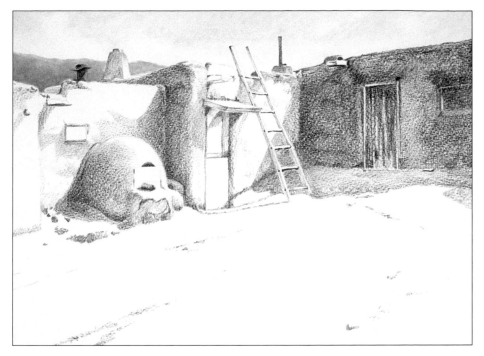

Step 3: Complete the Buildings and Begin the Blue Door and Small Window

Wet the lighter areas first with a clean, wet and blotted no. 6 brush. Work light areas into dark areas, continually keeping the brush clean. Tap on the darkest details with a slightly wet, clean no. 6 brush. Rewet areas with too much color using a clean, wet brush, then blot with a clean paper towel. Dry with a hair dryer.

Apply Lyra Blue-Violet, using a ruler to outline the darkest shadows in the frame of the blue door and the dark shadows in the small window. Apply Derwent Dark Violet with medium pressure for the dark shadows. Apply Dark Violet with lighter pressure and a sharp point to the outer portion of the blue door to show the shadow's patterns.

Apply Faber-Castell Azure Blue to the top part of the door in shadow, feathering the edges with Blue-Violet. Draw outlines around the patterns of the shadows in the bottom-outer portion of the door with a sharp Azure Blue. Add color to the small window using the same technique.

Apply Azure Blue with a sharp point and light pressure to color the metal drains above the blue door and the small window. Using the same technique, color parts of the metal plate in front of the oven. Use the reusable adhesive to leave white areas in the small window.

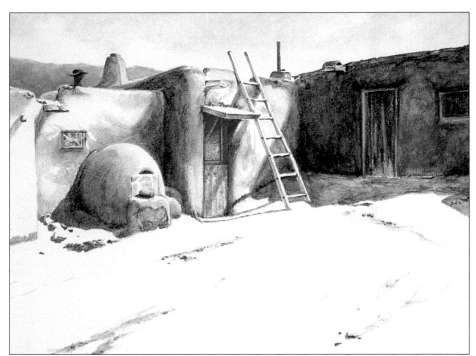

Step 4: Complete the Blue Door, Small Window, Metal, Buildings and Soil

Wet the lightest areas in the lower portion of the blue door with a blotted, clean no. 6 brush. Work into the darker areas with the tip of a damp brush to wet the details.

Apply Lyra Burnt Ochre lightly with a sharp pencil on the sunlit portion of the building. Leave the paper white on the lightest areas. Apply a few vertical strokes on the door in shadow.

Apply Derwent Burnt Carmine with a sharp point and medium pressure to the darkest areas throughout, including the footprints and car tracks in the foreground dirt. Apply vertical strokes of Burnt Ochre with a sharp point over the Burnt Carmine in the foreground.

Outline the right doorjamb on the blue door with a sharp Burnt Ochre and a ruler. Apply Burnt Ochre lightly on the bottom of the blue door.

Apply Faber-Castell Light Cobalt Blue and Cold Grey III to shadowed areas in the buildings.

Apply Dark Sepia with a sharp point under the ladder rungs. Apply Burnt Ochre and Derwent Blue-Grey with sharp points and light pressure to the shadowed side of the ladder.

Apply Lyra Rose Carmine and Faber-Castell Orange-Yellow using vertical strokes and sharp points to the door in shadow.

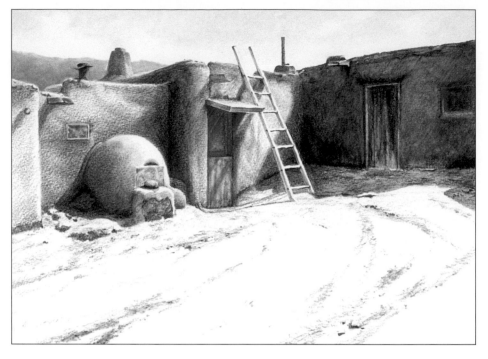

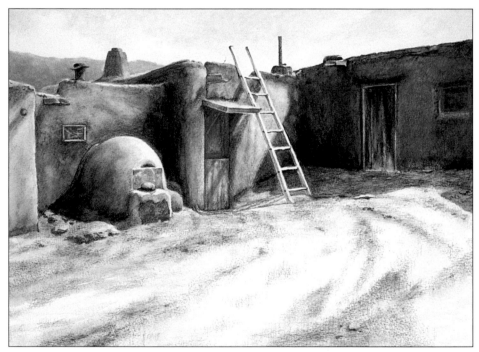

Step 5: Paint Buildings and Foreground Soil

Wet a no. 6 brush and gently blot it on a paper towel. Starting with the lightest areas between the ladder rungs, work the brush carefully into the area blotting with a paper towel as needed. Continue working lighter areas into darker areas as on the buildings. Dry with a hair dryer.

Wet the Burnt Ochre on the doorjamb of the blue door with a blotted no. 6 brush. Wet the lower blue door with a clean, blotted brush, and feather the Burnt Ochre upwards.

Apply a wash to the foreground soil with a very wet no. 12 round brush, gently touching the paper and pulling down in a vertical motion over the dry color. Allow to air dry.

Apply Blue-Grey with horizontal strokes and light pressure, drawing more details of the ground and rocks in the foreground.

Apply Lyra Brown Ochre with quick, vertical strokes over the foreground soil, following the paths of the tire tracks and footprints.

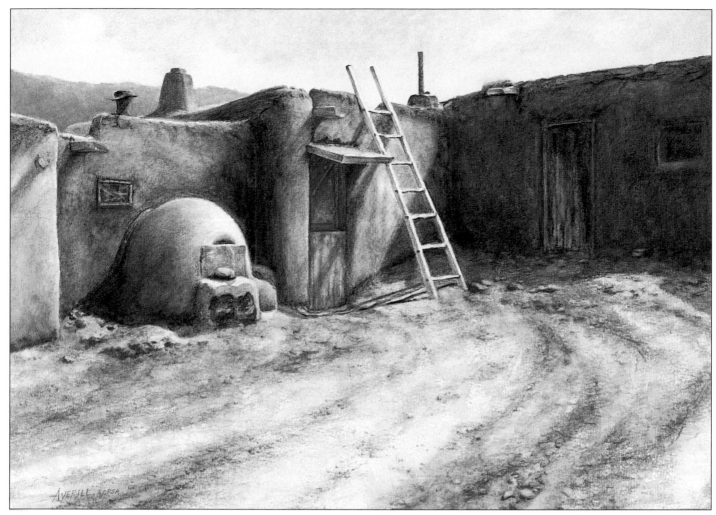

Step 6: Finishing Touches

Apply Dark Sepia with medium pressure and a rounded point over the building in shadow. Check perspective and add more Dark Sepia to the lower edge if necessary. Apply Dark Sepia with a sharp point to make cracks in the buildings.

Apply Derwent Madder Carmine with a sharp point for the left edges of trim on the small blue window. Then apply it to shadows on the rocks in the foreground.

Apply Derwent Blue-Grey with a sharp point and medium pressure into the foreground soil and rocks. Apply Lyra Brown Ochre with a sharp point and medium pressure for sunlit areas. Apply Derwent Madder Carmine over the shadows on the rocks in the foreground.

Tap a slightly wet no. 12 brush to the foreground area using downward strokes. Leave some areas of light.

Touch a clean, wet no. 6 brush to the point of Faber-Castell Tangerine. Tap the brush once gently on a paper towel and touch the white clouds. Add more water as needed to give the clouds a very light tint. Be careful not to contaminate the blue sky.

With a sharp pencil, stipple dots of Tangerine on the right side of the oven as close to the darks as possible. Wet with a no. 6 brush that has been blotted on a paper towel.

PUEBLO GEM
Pat Averill
10"×14" (25cm×36cm)
Wet-on-Dry Technique 1

Portland Wall
by Gary Greene
VARIOUS TECHNIQUES

A weathered stucco wall with exposed bricks offers an opportunity to showcase the versatility of water-soluble colored pencils. Can you depict the rich textures of the stucco or the mortar between the bricks with watercolors?

MATERIALS

22″ × 30″ (55cm × 75cm) 300-lb. (640gsm) Arches rough watercolor paper

no. 14 flat brush

nos. 6, 8 and 10 round watercolor brushes

no. 16 X-Acto blades

watercolor palette or small plastic container for dissolving color

spray bottle

2B graphite pencil

kneaded eraser

LAYOUT

The watercolor paper was washed in the sink and rinsed thoroughly to remove the sizing. The layout was completed first with a 2B graphite pencil, then redrawn with a Derwent Silver-Grey water-soluble pencil, placing the colored pencil lines next to (not on top) of the graphite lines. The layout was next erased with a kneaded eraser, which will remove the graphite lines and allow the colored pencil lines to remain.

Color Palette

CARAN D'ACHE
SUPRACOLOR II:
 Bluish Pale
 Greyish Beige

FABER-CASTELL
ALBRECHT DÜRER:
 Aquamarine
 Cedar Green
 Viridian
 Warm Grey III, IV

LYRA REMBRANDT
AQUARELL:
 Dark Orange
 Dark Sepia
 Grey-Green
 Indian Red
 Pompeian Red
 True Green
 Van Dyke Brown
 Venetian Red
 White

REXEL DERWENT
WATERCOLOUR:
 Silver-Grey

Step 1: Paint the Stucco Wall

Break several points from a Lyra Grey-Green pencil and place into a plastic palette cup. Fill the cup with water and allow it to stand overnight, or until the points are completely softened.

Wet the stucco area with a no. 14 flat brush. Add more water to the softened Grey-Green in the palette. Apply Grey-Green with a no. 10 round brush to the wet areas of the painting, using varying amounts of color to create a blotchy effect. Allow to dry thoroughly.

Apply dry Lyra True Green, Grey-Green, Faber-Castell Aquamarine, Viridian, Cedar Green and Caran d'Ache Bluish Pale over the Grey-Green underpainting. Lightly spray with water and dry with a hair dryer. Repeat until the desired effect is achieved.

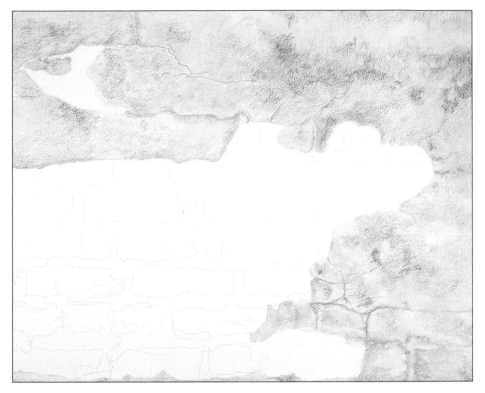

Step 2: Fill In the Mortar

Break two points from a Caran d'Ache Greyish Beige pencil and place them into a plastic palette cup. Fill the cup with water and allow it to stand overnight, or until points are completely softened.

Wet the mortar area with a no. 8 round brush. Apply highly diluted Caran d'Ache Greyish Beige with a no. 6 round brush to the wet areas of painting, using varying amounts of color to create a blotchy effect. Allow to dry thoroughly.

Stipple Caran d'Ache Greyish Beige and Faber-Castell Warm Grey III and V. Lightly spray with water and dry with a hair dryer. Repeat until the desired effect is achieved.

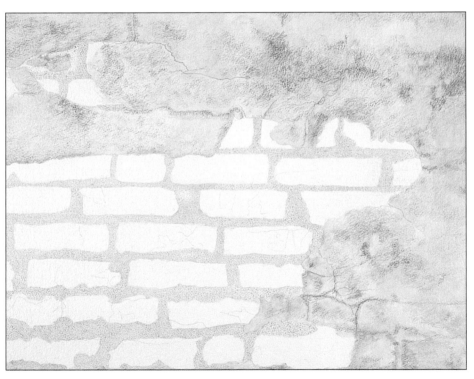

Step 3: Lay In the Bricks

Randomly apply Lyra Van Dyke Brown and Indian Red. Randomly apply various combinations of Lyra Pompeian Red, Venetian Red or Dark Orange to depict bricks. Apply water with a medium-wet no. 6 round brush, scrubbing some areas lighter than others. Do not entirely dissolve the pigment. Dry thoroughly with a hair dryer.

Scrape the pigment lightly with a sharp no. 16 X-Acto blade, being careful not to damage the paper surface. Blades should be changed often to prevent damage to the paper. Repeat this process for the desired effect. Lightly apply White to some of the bricks as shown.

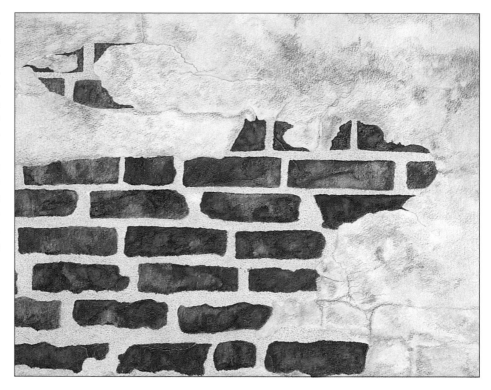

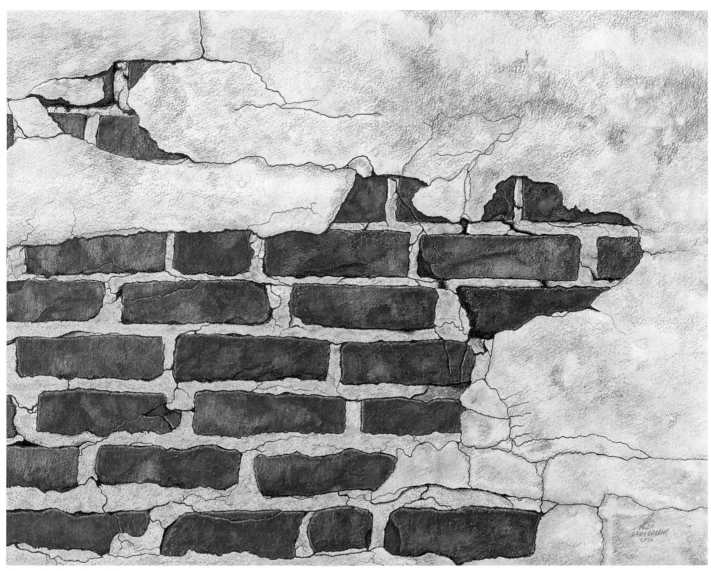

Step 4: Cracking Up

Lightly apply Caran d'Ache Greyish Beige randomly to the mortar area. Apply water with a medium-dry no. 4 round brush. Dry with a hair dryer. Randomly apply Lyra Dark Sepia to areas of some bricks. Apply water with a medium-wet no. 4 round brush and blend with the rest of the brick. Dry with a hair dryer. Randomly apply Dark Sepia to the negative spaces between the bricks and mortar. Apply water with a medium-dry no. 4 round brush. Dry with a hair dryer.

Draw cracks in the bricks, mortar and stucco with a sharp Dark Sepia pencil. Use a no. 16 X-Acto knife to lightly scrape a highlight next to the crack on the bricks only. Lightly scrape the top and left edges of the bricks with a no. 16 X-Acto knife. Lightly apply Lyra Pompeian Red over the scraped areas.

PORTLAND WALL
Gary Greene
14½″ × 18½″ (36cm × 46cm)
Various Techniques

Begonias
by Gary Greene
WET-ON-DRY TECHNIQUE 1

The strong contrast between red and white in the petals makes this painting noticeable from across a room. Various hues of red water-soluble colored pencils were applied, smudged with a cotton swab, then carefully wet to create a realistic effect.

MATERIALS

22″ × 30″ (55cm × 75cm) 140-lb. (300gsm) Lanaquarelle cold-press watercolor paper
nos. 6 and 8 round sable brushes
paper towels
cotton swabs

LAYOUT

An original transparency was projected onto paper and was traced with a Derwent Silver Grey water-soluble pencil.

Color Palette

FABER-CASTELL ALBRECHT DÜRER:
Apple Green
Cold Grey I, II, III, IV, V
Dark Carmine
Hooker's Green
Light Blue
Light Carmine
Light Orange
Moss Green
Sap Green
Tangerine

REXEL DERWENT WATERCOLOUR:
Madder Carmine

Step 1: Shadows

Apply Faber-Castell Cold Grey I, II or III and Light Blue to establish shadows, using strokes that follow the petal's contours. Wash with a medium-dry no. 6 brush.

Apply Faber-Castell Cold Grey III, Light Orange and Tangerine to the center of the flower. Wash with a medium-dry no. 6 brush.

Step 2: Petals

Painting one petal at a time, apply Derwent Madder Carmine, Faber-Castell Dark Carmine and Light Carmine to the edge of the petal, following the contour. Smudge with a dry cotton swab, and lightly apply the colors used in the first step.

Starting with an area free of pigment, gradually add water, working toward the edge using a wet no. 6 or no. 8 round brush (depending on the petal size). When the edge is reached, wipe the excess pigment into a paper towel. Drag strokes of pigment into the lighter area of petal. Dry with a hair dryer.

With a medium-wet no. 6 or no. 8 round brush, lighten the color and soften the strokes. Increase the lightening with a wet cotton swab.

Step 3: Leaves

Apply Faber-Castell Apple Green and Moss Green. With a no. 6 round brush moistened with a damp paper towel, blend the colors, leaving portions undissolved.

Apply Faber-Castell Hooker's Green and Sap Green. With a no. 6 round brush moistened from a damp paper towel, blend colors leaving portions undissolved.

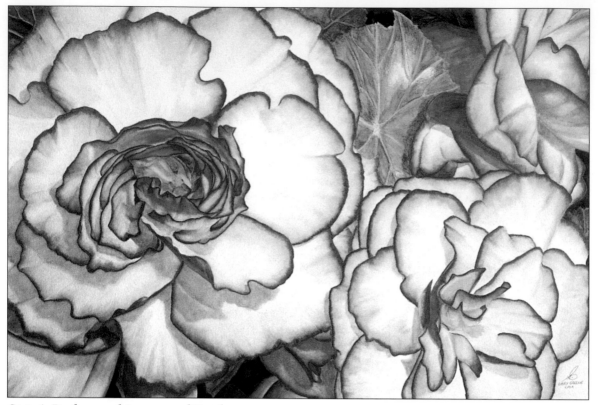

Step 4: Background Leaves and Petals

Apply Faber-Castell Cold Grey IV or V (depending on value) and Light Blue. Wash with a medium-wet no. 6 round brush. Apply Madder Carmine, Dark Carmine and Light Carmine for the background petals. Apply Apple Green, Moss Green, Hooker's Green and Sap Green for the leaves. Wash with a medium-wet no. 6 round brush.

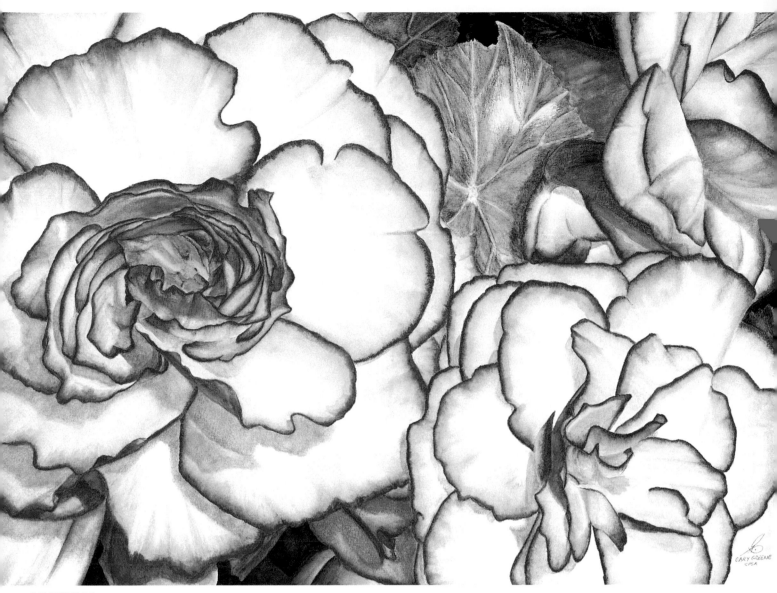

BEGONIAS
Gary Greene
12″×18″ (30cm×46cm)
Wet-on-Dry Technique 1

A Handful of Summer
by Shane
WET-ON-WET TECHNIQUE 2

Shane's light and airy painting has a definite watercolor look, created by applying color to a wet surface from a brush loaded with pigment obtained directly from the pencil.

MATERIALS

300-lb. (640gsm) Arches cold-press watercolor paper
nos. 3, 8 and 10 round watercolor brushes
nos. 1 and 4 flat bristle brushes
tracing paper
graphite paper
liquid mask
Incredible Nib by Grafix

LAYOUT

This painting was created from a reference photograph of a young girl holding a bouquet of flowers in front of her. The photo was in a vertical format. A layout sketch was done on tracing paper, and the format was changed to horizontal. The resulting composition was then transferred to the paper surface using artist's graphite paper. A bright pink colored pencil was used during the transfer to indicate what part of the sketch had been transferred.

Apply liquid masking agent with the Incredible Nib (a tool made for this purpose) to keep highlight areas of flowers free of color.

The general technique used was wet-on-wet; however, specific areas were moistened individually to control the flow of color.

Color Palette

FABER-CASTELL ALBRECHT DÜRER:

Blue-Violet	Light Carmine
Brown Ochre	Light Flesh
Burnt Ochre	Light Green
Canary Yellow	Light Phthalo Blue
Dark Flesh	Moss Green
Dark Sepia	Night Green
Dark Violet	Olive Green
Delft Blue	Pink Madder Lake
Fuchsia	Pompeian Red
Hooker's Green	Rose Carmine
Lemon	Sap Green

Step 1: The Face and Hands

Apply water to the facial area using a no. 10 brush. While the paper is still moist, load color onto wet no. 3 and no. 8 brushes by rubbing them on the tips of the colored pencils. Apply mixtures of Light Flesh, Dark Flesh and Burnt Ochre to the entire face and neck. Apply Burnt Ochre to define the cheeks and chin. Apply pale shades of Rose Carmine, Fuchsia and Blue-Violet to the cheeks and temple. Apply Dark Flesh and Rose Carmine to the lips. Apply Dark Flesh and Rose Carmine around the corners of the mouth and teeth.

Apply Night Green, Blue-Violet and Dark Sepia to the eye and forehead because these areas will be shaded by the hair. Allow the painted face to dry overnight.

Paint the hands using the same method and colors. Apply Light Carmine to the nails.

Make sure the areas painted previously are dry. Then remoisten the eyes, cheeks and neck and reapply the same colors over the previous layers. This technique, known as *glazing*, results in darker values and a deeper saturation.

Apply Dark Sepia, Light Green and Hooker's Green with a moistened no. 3 brush to the areas around the eyes and mouth.

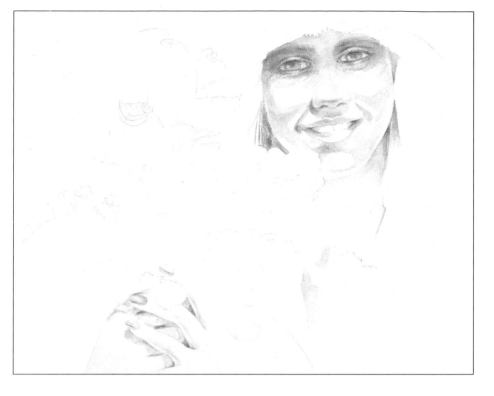

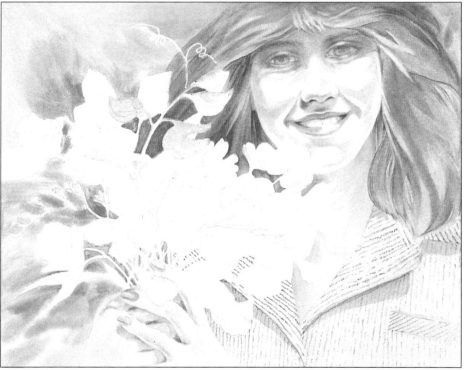

Step 2: Begin the Shirt and Background

Soak the shirt area with no. 8 and no. 10 brushes. While the paper is still wet, dip the tip of the Night Green pencil in water and draw the lines of the shirt. Paint the hair, using wet paper and moistened pencils, with Dark Sepia, Burnt Ochre and Brown Ochre. Use a wet no. 8 brush to soften the area. After drying, pull out the initial highlights using wet no. 1 and no. 4 flat bristle brushes.

Flood the background behind the flowers with clear water using a no. 8 brush. Apply Night Green and Hooker's Green with the same no. 8 brush.

Step 3: Paint the Flowers

Paint the basic forms of the sweet peas with Rose Carmine, Pink Madder Lake, Light Carmine, Pompeian Red and Fuchsia. Paint the freesia with Light Phthalo Blue, Delft Blue, Dark Violet and Canary Yellow. Paint the daisies with Brown Ochre, Burnt Ochre, Lemon and Canary Yellow using a no. 3 brush and a pencil dipped in water. Before the color dries, blend some of the areas with the same brush. You can still see lines on some of the sweet peas. This demonstrates that color can be directly applied with a moistened colored pencil and left as is, or blended with a moistened brush.

Paint basic leaf and stem shapes on wet paper with moistened Hooker's Green, Sap Green, Olive Green and Moss Green pencils using a no. 3 round brush.

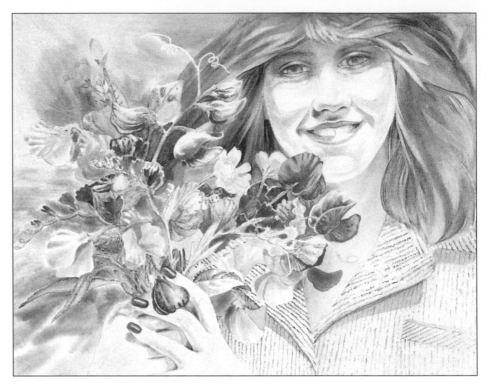

Step 4: The Final Touches

Moisten the shirt with clear water. This should be done quickly so you don't disturb the color already laid down. Wash over this area with a predissolved mixture of Night Green using a no. 10 round brush. Using the same technique, darken the background with Night Green and Hooker's Green. Reapply the same wash to the girl's shirt and neck.

Moisten the petals and apply the final details to the flowers, petals and stems. Draw veins on some flowers with pencil tips dipped in water. Allow some lines to dry, and blend others with wet no. 3 and no. 8 brushes. Add another glaze of Night Green to the left eye and bottom of the chin. (This is reflected color from the shirt.)

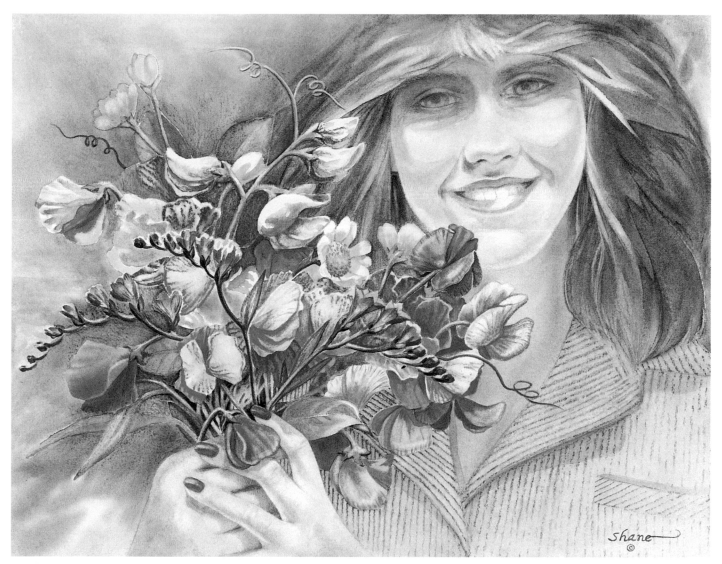

A HANDFUL OF SUMMER
Shane
10¾″ × 13¾″ (27cm × 35cm)
Wet-on-Wet Technique 2

Liquid Fuchsias
by Gary Greene
WET-ON-WET AND DRY-ON-WET TECHNIQUES

Although this painting is technically done with water-soluble colored pencils, there's no way anyone would think it was done with anything but watercolor. After masking the fuchsias, the background was applied on a wet surface with water-soluble colored pencils dissolved in water. Then the other parts of the flower were individually painted in the same manner, except for the red variegations.

MATERIALS
- 22″×30″ (55cm×75cm) 300-lb. (640gsm) Arches rough watercolor paper
- no. 14 flat brush
- nos. 4, 6, 8 and 10 round watercolor brushes
- nos. 4 and 9 student-grade round brushes (for applying liquid frisket)
- liquid frisket
- kneaded eraser
- watercolor palette or small plastic container for dissolving color
- cotton swabs
- paper towels

LAYOUT
The paper was washed in the sink and rinsed thoroughly to remove sizing. Then the original transparency was projected onto paper and the image was traced with a Derwent Silver-Grey water-soluble pencil.

Color Palette

FABER-CASTELL ALBRECHT DÜRER:
Warm Grey III, V

LYRA REMBRANDT AQUARELL:

Apple Green	Indian Red
Blue-Violet	Light Carmine
Brown Ochre	Light Violet
Canary Yellow	Moss Green
Cream	Rose Carmine
Dark Carmine	Magenta
Dark Violet	

REXEL DERWENT WATERCOLOUR:
Madder Carmine

Step 1: Begin in the Background
Apply liquid frisket to flowers with a no. 6 student-grade round brush. Allow to dry overnight—do not dry with a hair dryer.

Break off several points of Lyra Light Violet and Canary Yellow pencils and place in separate watercolor palettes. Moisten the points with water and allow them to soak for approximately thirty minutes. Stir with a small brush.

Flood the paper with water, using a no. 14 flat brush. Apply the liquefied Canary Yellow with a no. 14 flat brush. Apply liquefied Light Violet with a no. 14 flat brush. Allow to dry overnight—do not dry with a hair dryer. Remove the frisket and redraw the layout lines as necessary.

Step 2: Paint the Purple Petals

Reapply the frisket to the stamens within the body of the flower and the edges of the petals with a no. 4 student-grade round brush as shown. Allow to air dry—do not dry with a hair dryer.

Break off points of Lyra Magenta and Dark Violet pencils, placing them in the same palette container. Break off the point of a Lyra Blue-Violet and place it in a separate palette container. Add a small amount of water and allow this to stand for five to ten minutes, or until the points are soft.

Working one petal at a time, apply water to the paper with a no. 10 round brush. Allow the water to soak in slightly. With a round brush of appropriate size for the area to be worked, apply a liquid mixture of Dark Violet and Magenta to the darkest areas first. Blend with a moist brush.

Continue adding and blending the color. Add a small amount of water to lighten areas as necessary. Dip a cotton swab in water and gently apply it to the painted area to erase color.

Apply a mixture of Dark Violet, Magenta and Blue-Violet to the shadow areas. If the area being painted is too liquid and color starts to spread, blot it with cotton swab. Dry with a hair dryer before starting the next petal.

Remove the frisket from the edges of the petals and stamens. Using a moistened no. 6 round brush, drag color from the surrounding area into the exposed white edges of the petals.

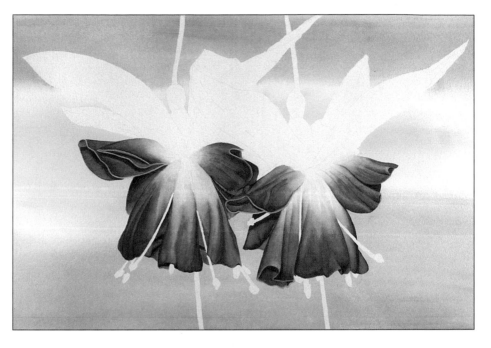

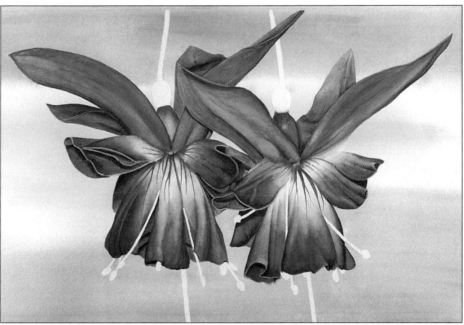

Step 3: Paint the Red Petals

Break off points of Derwent Madder Carmine, Lyra Dark Carmine, Light Carmine and Rose Carmine pencils. Place in separate palette containers. Add a small amount of water to each and allow to stand for five to ten minutes, or until points are soft.

Working one petal at a time, apply water to the area to be painted with a no. 10 round brush. Allow the water to soak in slightly.

With a round brush of appropriate size for the area to be worked, apply a liquid mixture of Derwent Madder Carmine, Lyra Dark Carmine and Rose Carmine to the darkest areas first. Blend with a moist brush. Clean the brush and apply a liquid mixture of Lyra Light Carmine and Rose Carmine.

Repeat, adding and blending the color. To lighten, add a small amount of water to the brush as necessary. Dip a cotton swab in water and gently apply to the painted area to erase color. Reapply the mixture of Derwent Madder Carmine, Lyra Dark Carmine and Rose Carmine to the shadow areas. Dry with a hair dryer before starting the next petal. Dip the rounded Rose Carmine pencil into water and apply it lightly to depict red variegations. Blend with a no. 4 round brush moistened only from a wet paper towel.

Step 4: Final Details

Stamen—With a medium-wet no. 4 round brush, wet the areas to be painted. Paint the darker values on the light yellow tips with Faber-Castell Warm Grey III by brushing pigment from the point of the pencil. Dry with a hair dryer. Moisten slightly with water and paint with Lyra Cream by bruising pigment from the point of the pencil. Dry with a hair dryer. Slightly moisten the remaining red areas one at a time with a combination of Derwent Madder Carmine, Lyra Dark Carmine and Rose Carmine. The color should be more concentrated than that used with the red petals. Allow to dry.

Pod—Break off points of Lyra Moss Green, Apple Green, Brown Ochre and Indian Red. Place in separate palette containers. Add a small amount of water to each and allow to stand for five to ten minutes, or until the points are soft. Wet the area to be painted with a medium-wet no. 6 round brush. Allow the water to soak in slightly. Apply a liquid mixture of Lyra Moss Green and Apple Green. Blend with a moist brush. Reapply as necessary. Leave the highlight free of color. Dry with a hair dryer.

Stem—Wet the area to be painted with a medium-wet no. 4 round brush. Allow the water to soak in slightly. Apply a thinned liquid mixture of Lyra Brown Ochre. Blend

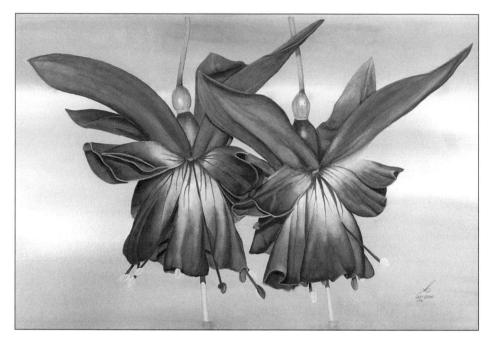

with a moist brush. Reapply as necessary. Paint the shadow area with Faber-Castell Warm Grey V by brushing pigment from the point of the pencil. Dry with a hair dryer. Apply Lyra Brown Ochre over the shadow area by brushing pigment from the point of the pencil. Brush pigment from the point of a Lyra Indian Red pencil and apply to the stem and pod as shown.

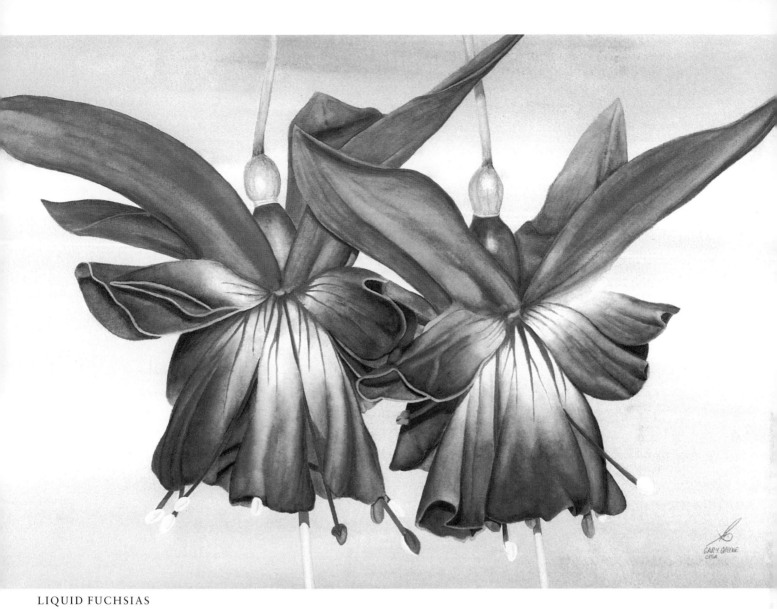

LIQUID FUCHSIAS
Gary Greene
17¼" × 26" (44cm × 66cm)
Wet-on-Wet and Dry-on-Wet Techniques

Flower Power 3

by Gary Greene

WET-ON-DRY TECHNIQUE 2 AND WAX-BASED COLORED PENCIL

This attention-getting side view of a brightly colored dahlia consists of a combination of glazes of gray and yellow water-soluble colored pencils with burnished layers of wax-based red pencil on top. Although this painting is 50 percent "dry" colored pencil, it demonstrates how well water-soluble colored pencils work in combination with wax- or oil-based colored pencils.

MATERIALS

22" × 30" (55cm × 75cm) 140-lb. (300gsm) Lanaquarelle cold-press watercolor paper
nos. 6 and 8 round sable brush
paper towels
Lyra Splender pencil

LAYOUT

The original transparency was projected onto paper. The image was traced with a Faber Castell Albrecht Durer Warm Grey II water-soluble pencil.

Color Palette

CARAN D'ACHE SUPRACOLOR II:
Canary Yellow	Lemon Yellow
Golden Ochre	Spring Green
Golden Yellow	Yellow

FABER-CASTELL ALBRECHT DÜRER:
Warm Grey II, III, IV, V, VI

SANFORD PRISMACOLOR:
Crimson Red	Pumpkin Orange
French Grey 30%, 50%,	Scarlet Lake
70% and 90%	Tuscan Red
Goldenrod	Vermilion
Indigo Blue	Yellowed Orange
Orange	Yellow Ochre
Poppy Red	

SANFORD VERITHIN:
Black	Orange Ochre
Carmine Red	Tuscan Red
Lemon Yellow	

Step 1: Paint the Shadows

With strokes that follow the petal's contours, apply Faber-Castell Warm Grey III, IV or V (depending on value) to establish shadows. Wash with a medium-dry no. 6 brush.

Step 2: Paint Yellow on the Petals

Working one petal at a time, apply Caran d'Ache Golden Ochre over the gray shadow areas (as described in step 1) and to the areas of lighter dark values. Wash with a medium-wet no. 6 or no. 8 brush, depending on the size of the area to be covered. Dry thoroughly with a hair dryer.

Apply Caran d'Ache Spring Green to some grey shadow areas at the center of the flower. Wash with a medium wet no. 6 brush. Dry thoroughly with a hair dryer.

Apply, in sequence: Caran d'Ache Golden Yellow, Yellow, Canary Yellow and Lemon Yellow. Wash with a no. 6 or no. 8 brush and dry with a hair dryer between each application of color, extending the color into the body of the petal.

Step 3: Enhance Shadows and Red Portion of Petals

Working one shadow area at a time, enhance the cast shadows as needed with Prismacolor French Grey 30%, 50% or 70% (depending on value) using light to medium pressure. Apply Prismacolor Goldenrod or Yellow Ochre (depending on value) over the gray. With heavy pressure, burnish with a Lyra Splender pencil until all of the paper surface disappears. Reapply Goldenrod or Yellow Ochre, as required.

Working one petal at a time, lightly apply Prismacolor French Grey 70% or 90%, Tuscan Red and Pumpkin Orange for the darkest cast shadows of the red areas of the petals. Omit French Grey for lighter cast shadows and contour shadows.

With light to medium pressure, apply (in sequence) gradations of Prismacolor Crimson Red, Scarlet Lake, Poppy Red, Vermilion, Yellowed Orange (to center petals only) and Orange. Red wax-based pencils give off a significant amount of debris; keep the paper surface clean at all times. With heavy pressure, burnish with a Lyra Splender pencil until all the paper surface disappears, leaving some of the orange areas unburnished. Reapply Crimson Red, Scarlet Lake, Poppy Red, Vermilion and Orange, as required. Sharpen petal edges with Verithin Tuscan Red, Carmine Red or Orange Ochre.

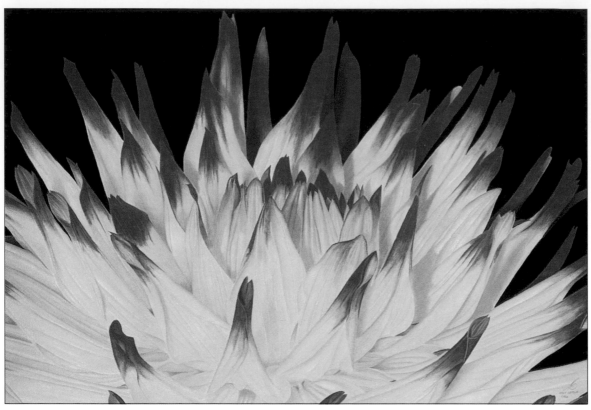

Step 4: Complete the Background

All strokes, both wet and dry, should be applied in the same direction: vertically. Apply Faber-Castell Warm Grey VI, stopping approximately ⅟₃₂″ (8mm) from the edge of the petals. Wash with a medium-wet no. 6 or no. 8 round brush, using the smaller brush for tighter areas, retaining the same ⅟₃₂″ (8mm) edge. Dry thoroughly with a hair dryer.

Apply a medium layer of Tuscan Red and Indigo Blue. Bring the background up to the edge of the petals with Black Verithin. With heavy pressure, burnish with a Lyra Splender pencil until all the paper surface disappears. Reapply Indigo Blue, making sure the entire paper surface is covered. Darken the edges of the petals with Tuscan Red, Carmine Red, Orange Ochre or Lemon Yellow Verithin, as necessary.

FLOWER POWER
Gary Greene
17" × 24" (43cm × 61cm)
Wet-on-Dry Technique 2 and Wax-Based Colored Pencil

Brannon III

by Bonnie Auten

WET-ON-DRY TECHNIQUE 2

Bonnie's dramatic portrait not only shows her artistic ability, but also shows the ability of water-soluble colored pencils to depict subtle flesh tones and textures.

MATERIALS

Arches 400-lb. (850gsm) watercolor paper
¾-inch (1.9cm) flat brush
no. 12 flat brush
no. 6 filbert brush
no. 4 line brush
tortillion
small hair dryer
masking fluid
Incredible Nib by Grafix

LAYOUT

Trace the original outline drawing onto Arches 400-lb. (850gsm) cold-press water-color paper with a Dark Grey Verithin. Apply a thick line of masking fluid with an Incredible Nib to the eye, the shadow line of the right eye, the right side of the face, the ear and the scar on the forehead and beneath the hair on the left side of the head.

Color Palette

BRUYNZEEL DESIGN AQUAREL:

Burnt Ochre	Light Violet
Dark Brown	Prussian Blue
Dark Green	Sienna
Dark Grey	Sky Blue

LYRA REMBRANDT AQUARELL:

Black	Juniper Green
Brown Ochre	Light Flesh
Burnt Ochre	Medium Flesh
Burnt Sienna	Medium Grey
Cinnamon	Night Green
Cool Silver Grey	Sap Green
Cream	Sky Blue
Dark Carmine	Raw Sienna
Dark Flesh	Red-Violet
Dark Grey	True Blue
Dark Sepia	Van Dyke Brown
Gold Ochre	Wite

SANFORD VERITHIN:

Black
Dark Grey

Step 1: Begin the Face

Apply a layer of Bruynzeel Dark Grey to the darkest shadow areas of the face, including the eyebrows and mustache. Blend with a damp no. 12 flat brush. Dry with a hair dryer. Apply Bruynzeel Prussian Blue over the Dark Grey and upper portion of the background. Blend with a damp no. 12 flat brush. Dry with a hair dryer. Apply a layer of Lyra Juniper Green to the upper background and blend with your finger. Blend the entire area with a damp no. 12 flat brush. Dry with a hair dryer. Apply a layer of Bruynzeel Sky Blue over the entire background in vertical strokes. Blend slightly with your finger. Blend with barely damp no. 12 flat brush.

Repeat this procedure (without vertical strokes) on the entire background using layers of Bruynzeel Dark Green, Lyra Night Green and Sap Green.

To create the skin shadows, apply a layer of Lyra Dark Sepia in the deepest shadows and to the left side of the face. Blend with a barely damp no. 12 flat brush. Apply separate layers of Bruynzeel Sienna and Dark Brown to the dark areas of the left eye. Blend each layer with a damp no. 6 filbert brush. Do not overwork.

Apply a layer of Lyra Van Dyke Brown, Brown Ochre, Cinnamon and Bruynzeel Burnt Ochre. Proceed with a barely damp no. 12 or ¾-inch (1.9cm) flat brush to larger areas in the darkest areas on the left side of the face. Blend each color first with your finger or a tortillion to disperse the pigment evenly. Do not overwork the areas. Completely dry each layer before proceeding to the next. Work the colors over the eyebrow and mustache areas, the darkest skin areas, and the hair area on the right side of the head.

Apply a light layer of Lyra Black into the mustache and eyebrow area. Blend with a damp no. 6 filbert brush, following the growth of hair when needed.

Step 2: Remove the Masking.

Remove all the masking fluid by rubbing very gently with a kneaded eraser. Leave the lower-left hair area intact. Apply a layer of Lyra Dark Flesh over the entire left side of the face, left side of the nose, under the right eye and the lips. Blend gently with your finger. Blend the entire area with a damp no. 12 flat brush. Work small areas at a time with very little pressure on the brush. Blend the lower right eye using the no. 6 filbert brush. Dry with a hair dryer

Apply a light layer of Lyra Cinnamon, Burnt Ochre and Dark Flesh to the right side of the face. Blend with a wet no. 12 flat brush. Blend colors into the white areas of the face with a wet no. 12 flat brush and clean water. Dry with a hair dryer.

Apply a layer of Lyra Dark Flesh into the lips, right ear and the lighter portion of the right side of the nose. Apply a layer of Lyra Dark Carmine in the deep shadow of the lips and Lyra Cream in the highlight of the upper lip. Blend with a slightly damp no. 6 filbert brush. Apply a light layer of Lyra Red-Violet into the shadows of the mouth on the right, in the deepest shadows under each eye, and along the bridge of the nose. Blend with a no. 12 flat brush, barely touching the paper.

Step 3: Paint the Eyes and Forehead

Apply a layer of Lyra Van Dyke Brown. Leave the paper free of color for the highlights. Apply a layer of Lyra Brown Ochre and Gold Ochre in the lightest areas of the right eye. Apply a layer of Lyra Dark Sepia to the outline of the eye and the dark area around pupil and lashes. Blend with a no. 4 line brush. Dry with a hair dryer between layers. Leave an area in each eye open for white reflection or apply reflection with Lyra White.

To create the whites of the eyes, apply a layer of Bruynzeel Light Violet and Lyra Cool Silver Grey. Apply Lyra True Blue in the deepest areas very lightly into the white area. Blend with a barely damp no. 4 line brush. Apply a layer of Lyra Dark Flesh under the lid and in the eye corners. Apply Lyra Black as the last layer of the eyelashes and the deepest part of the eyes. Blend with a wet no. 4 line brush. Dry with a hair dryer.

To create the forehead, deepen the shadows with layers of Lyra Burnt Ochre, Dark Grey and Dark Brown. Apply Dark Sepia in the areas around the upper hand and to the hair on the left. Blend with a tortillion to even out the complexion. Use the same method on the lower left side of the face with Lyra Burnt Ochre, Dark Flesh, Raw Sienna and Gold Ochre. Do not blend with a brush. Add facial hair with layers of Lyra Dark Sepia, using an uneven stroke. Blend with a tortillion.

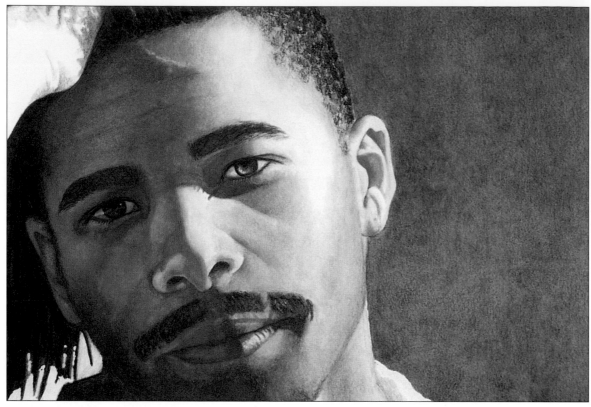

Step 4: Complete the Hair, Upper Hand, Eyebrows and Shirt

Apply a layer of Lyra Dark Grey. Blend with a no. 9 filbert brush. Apply Lyra Black with a heavy uneven stroke. Blend with a moderately wet no. 9 filbert brush, and dry with a hair dryer. Separately apply heavy applications of Lyra Black, Dark Sepia and Dark Grey to the right side of head and hair area. Blend with a barely damp no. 6 filbert brush.

To complete the upper hand, layer Lyra Dark Grey with an uneven stroke. Blend with a no. 6 filbert brush and dry with a hair dryer. Darken the shadows with Dark Sepia and Lyra Van Dyke Brown. Use a no. 6 filbert to blend the pigment in a spidery pattern. Dry completely. Apply Lyra Medium Flesh to the entire arm and lightest hand area. Blend with a wet no. 12 flat brush and dry with a hair dryer. Apply Lyra Burnt Sienna and Gold Ochre in the lower wrist area. Blend with a barely damp no. 4 line brush and dry with a hair dryer. Apply Lyra Light Flesh to the arm as needed. Blend with a damp no. 12 flat brush.

To complete the eyebrows, mustache and nostrils, apply a layer of Lyra Dark Sepia, Dark Grey and Black. Use a brisk stroke, applied unevenly to the hair. Blend the pigment very lightly with a slightly damp no. 6 filbert brush. Dry with a hair dryer between layers. Apply Lyra Cream to the highlighted areas of the mustache. Blend with a barely damp no. 6 line brush using hair-like strokes.

To paint the shirt, apply a layer of Lyra True Blue, Medium Grey and Cool Silver Grey to the shirt on both sides, leaving white areas. Blend with a moderately damp no. 12 flat brush. Layer Lyra Dark Grey, Dark Sepia and Van Dyke Brown, applying separately. Blend with a damp no. 12 flat brush. Dry with a hair dryer. Leave some white areas free of color.

Apply Lyra Sky Blue to the background around the ear. Blend with tortillion. Apply Juniper Green to the lower portion of the background. Blend with a no. 12 flat brush and dry with a hair dryer.

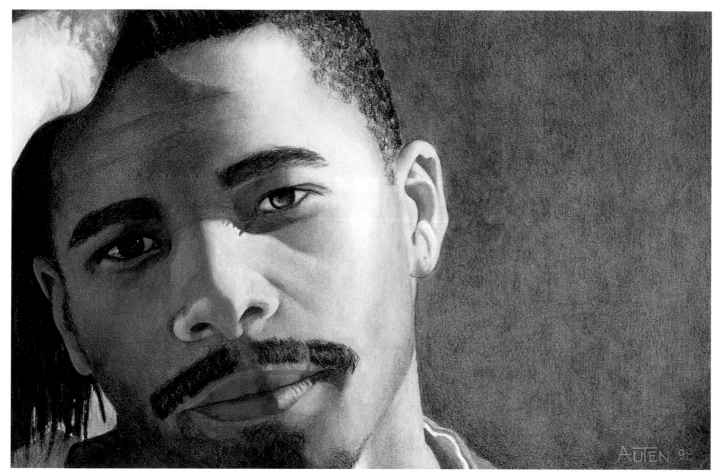

BRANNON III
Bonnie Auten
11" × 17" (28cm × 43cm)
Wet-on-Dry Technique 2

Character Sketch

by Bernard Poulin

WET-ON-DRY TECHNIQUE 1

Bernard's elegant, loosely rendered painting demonstrates another dimension to water applied to water-soluble colored pencils layered dry to dry paper.

MATERIALS

Arches Satine watercolor paper
no. 26 sable watercolor brush
artist's sponge
tissue

LAYOUT

The outline of the head and slumped shoulders are sketched using a thumbnail drawing as reference. Rexel Derwent Blue-Violet Lake is used for the sketch.

Color Palette

BRUYNZEEL DESIGN AQUAREL:
Phthalo Green

FABER-CASTELL ALBRECHT DÜRER:
Dark Orange
Tangerine
Wine Red

REXEL DERWENT WATERCOLOUR:
Bottle Green
Imperial Purple
Indigo
Rose Pink

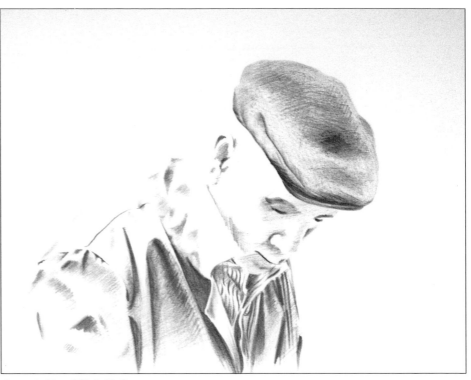

Step 1: Establish Values
Using loose, diagonal strokes and hatches to establish tonal values on the coat, hat and shirt, apply Bruynzeel Phthalo Green, Derwent Bottle Green and Imperial Purple respectively.

Step 2: *Wash and Draw*

Wash the entire painting with a wet no. 26 sable watercolor brush, allowing the colors to flow freely from the subject into the background. With Derwent Imperial Purple, redraw the features and parameters of the head to indicate accent points in the clothing while the surface is still wet.

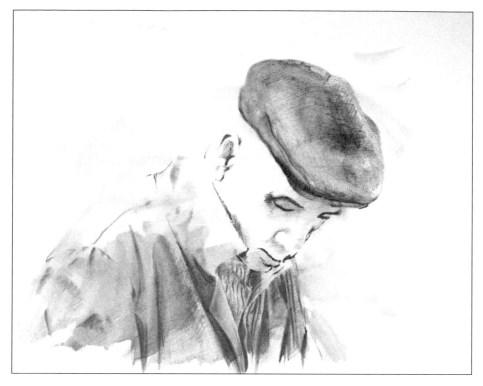

Step 3: *Emphasize Values*

Apply Faber-Castell Wine Red to emphasize the tonal values of the shadow areas on the face and the tonal value definitions of the hat, coat and shirt. Apply Faber-Castell Tangerine to ruddy the cheeks, ear and nose.

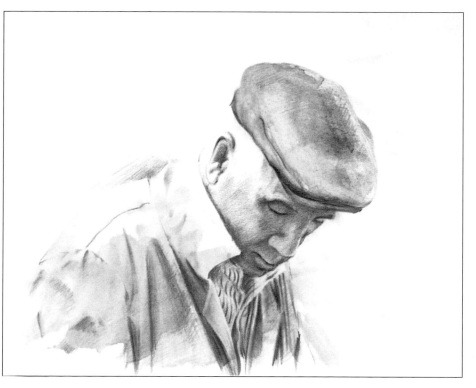

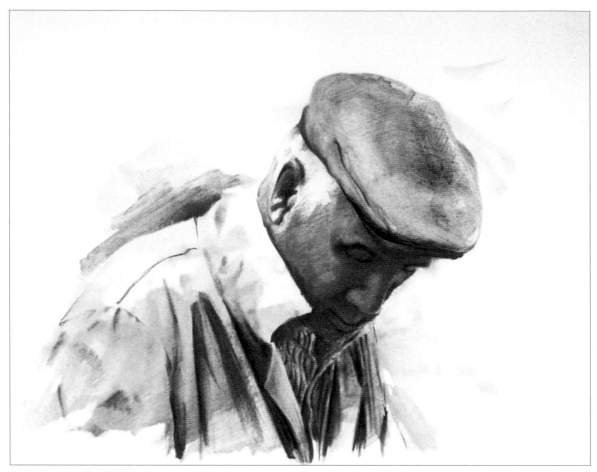

Step 4: The Final Touches

Apply Derwent Imperial Purple and Faber-Castell Dark Orange to intensify the shadow areas of the face. Apply water to areas that become too dark and intense with a no. 26 brush and sponge. Blot the excess water with a tissue.

Redraw the darks of the eyes, nose and clothing areas with Derwent Indigo and Bottle Green. Apply Derwent Rose Pink to soften the mid-range skin colors.

With a damp watercolor brush, soften the facial colors as needed. Redraw facial features that may become washed out due to water applications.

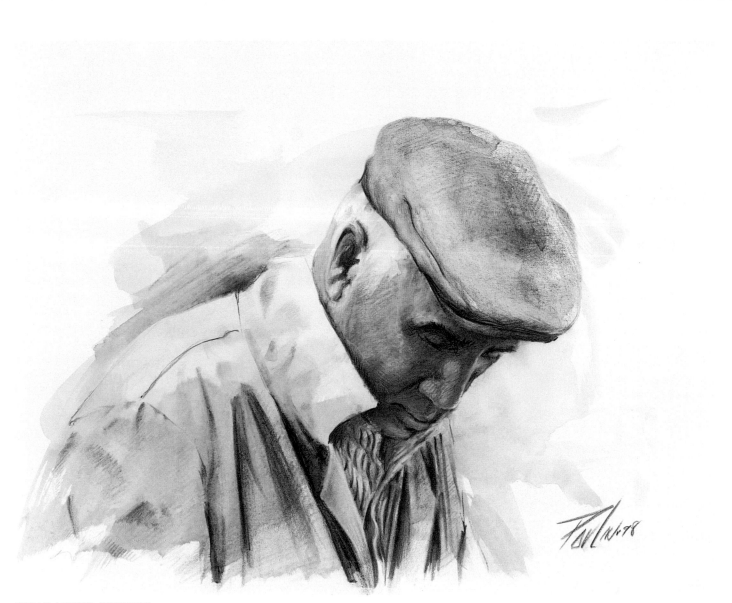

CHARACTER SKETCH
Bernard Poulin
9" × 12" (23cm × 30cm)
Wet-on-Dry Technique 1

Lunch Break
by Rhonda Farfan
WET-ON-DRY TECHNIQUE 3

In this whimsical, imaginative painting, Rhonda masked her subjects and applied broad strokes of water-soluble colored pencils pigment with foam or mop brushes and natural sponges. She later painted in details with round brushes of varying sizes.

MATERIALS
- 24″ × 20″ (60cm × 50cm) Bainbridge Alpha Rag four-ply museum board
- 1-inch (2.5cm) foam-tipped poly brush
- ¼-inch (63mm) flat mop brush
- detail mop brush
- no. 10 flat brush
- nos. 0, 1, 3 and 5 round brushes
- frisket paper
- liquid frisket
- assorted natural cosmetic sponges

LAYOUT
A simple, cartoon-like contour drawing was done from imagination on tracing paper in a very small format (3¼″ × 2½″ [7cm × 6cm]) using a no. 2 graphite pencil. To differentiate the plants from the animals, I went over the plant outlines with a colored pencil. The small drawing was projected onto a 24″ × 20″ (60cm × 50cm) piece of Bainbridge Alpha Rag four-ply museum board and transferred with a graphite pencil. A two-inch border was included as part of the drawing.

This technique consists of applying water-soluble pencil tips to damp brushes or sponges, and applying this pigment to dry paper.

Color Palette

BRUYNZEEL DESIGN AQUARELL:

Black	Light Yellow
Lemon Yellow	Moss Green
Light Green	Prussian Blue
Light Ochre	Umber
Light Red	Yellow-Green

LYRA REMBRANDT AQUARELL:

Black Medium	Night Green
Dark Orange	Oriental Blue
Dark Sepia	Peacock Blue
Delft Blue	Prussian Blue
Emerald Green	Scarlet Lake
Lemon Cadmium	True Blue
Light Chrome	Viridian
Light Green	White
Light Ochre	Wine Red

REXEL DERWENT WATERCOLOUR:

Blue-Grey	Jade Green
Bronze	Madder Carmine
Flesh Pink	Mineral Green
French Grey	Scarlet Lake
Gunmetal	Zinc Yellow
Indigo	

Step 1: Paint the Water and Sky

Apply Derwent Blue-Grey with a dampened 1-inch (2.5cm) foam-tipped poly brush. Lightly wash all underwater surfaces, including rocks, plants and animals. Repeat for the sky area. Blend with 1-inch (2.5cm) foam-tipped poly brush for smoothness.

Apply Derwent Indigo with a combination of the 1-inch (2.5cm) foam brush for the larger areas and a ¼-inch (63mm) flat mop brush for the smaller areas, washing the underwater and rock surfaces. Don't wash over plants and animals at this time. Allow to dry.

Wash the sky with Lyra Aquarell True Blue and a narrow wash of Derwent Zinc Yellow along the horizon with a 1-inch (2.5cm) foam brush. Apply a wash of Derwent Indigo and Lyra Prussian Blue along the top edge of the inner picture (inside border) edge. Reapply Lyra True Blue washes until the desired intensity is reached. Blend with 1-inch (2.5cm) foam brush for smoothness, drying between washes.

Paint the water currents with a wet Lyra Dark Orange, Delft Blue, True Blue and Bruynzeel Lemon Yellow. Blend with ¼-inch (63mm) flat mop brush as you go. Allow to dry.

Mask all plants and edges of the animals with frisket film or liquid frisket, applied thickly with a no. 10 flat brush, and wash all underwater areas except the rocks. Apply Lyra Oriental Blue with a 1-inch (2.5cm) foam brush. Dry between washes. Dry completely before removing masking.

Step 2: Paint the Rocks

Mask the salamander and seaweed above the water line and the seaweed above and below the water line of underwater rocks with liquid frisket and a no. 10 flat brush. Mask the painted sky and water touching rocks with frisket paper.

Apply wet pencil to several slightly dampened natural sponges. Dab on the colors in the following sequence: Derwent Bronze, French Grey, Scarlet Lake, Lyra Delft Blue, Bruynzeel Moss Green, Lyra Dark Sepia, Bruynzeel Umber, Lyra Light Ochre, Bruynzeel Black. Reapply Derwent Bronze as a last layer. Dry between layers until the desired rock-like effect is achieved. Dabbing on more dark colors makes darker rocks; using lighter colors makes lighter rocks.

Remove the frisket film from the sky and water. Dampen a no. 3 round brush with

Derwent Bronze and Bruynzeel Umber and smooth out the rock edges. Add cracks and holes with Bruynzeel Black.

Step 3: Create the Seaweed and Anemones

Blend washes of Lyra Delft Blue, Night Green, Viridian and Emerald Green with a dampened no. 3 round brush, beginning with floating seaweed below the waterline. Continue to work upward, blending toward the seaweed above the water with Lyra Scarlet Lake, Derwent Mineral Green, Lyra Light Green and Bruynzeel Yellow-Green. Blend all floating seaweed with a wash of Derwent Jade Green, working above and below the waterline with a no. 3 round brush. Repeat the process for the underwater seaweed plant.

Dab on Lyra Night Green with a small piece of natural sponge to depict the texture of seaweed. Repeat with Bruynzeel Light Ochre over all the seaweed plants. Dab Bruynzeel Yellow-Green over all the seaweed with a no. 3 round brush.

Apply Lyra Delft Blue with a no. 1 round brush to strengthen the dark edges of the seaweed. Paint the waterline and strengthen the upper seaweed edge along the rocks with Lyra Viridian. Dab Lyra Light Chrome on the upper and lower parts of the floating seaweed. Repeat the texturing process explained in the previous paragraph, if desired.

With a small piece of natural sponge for texture, dab on Derwent Gunmetal over the entire anemone plant. Allow to dry.

Apply Lyra Wine Red with a wet ¼-inch (63mm) flat mop brush on the tops of the

anemone. Blend downward with Derwent Flesh Pink. Allow to dry. Repeat to achieve the desired intensity.

To create shadows, apply Lyra Delft Blue using a ¼-inch (63mm) flat mop brush and a no. 5 round brush for narrow areas. Blend with the ¼-inch (63mm) flat mop brush and Derwent Flesh Pink. Repeat for desired intensity.

Apply Lyra Lemon Cadmium on the tops of the anemone and blend. Apply Lyra Dark Orange and blend downward.

Apply Lyra True Blue and Bruynzeel Umber with a no. 1 round brush to paint the small areas of anemone. Clean up the edges where the anemone touches water and rocks.

Step 4: Paint the Salamander and Turtle

With a no. 0 or no. 1 round student-grade brush, mask the salamander's white spots, white line and eye highlight with liquid frisket. Allow to dry.

Apply Derwent Madder Carmine with a flat detail mop brush to depict the salamander's spotted areas. Repeat for desired intensity. Working from inside the mouth outward, paint the tongue with Lyra Delft Blue, Scarlet Lake and Lemon Cadmium. Blend with a damp detail mop brush and repeat for the desired intensity.

Apply Lyra Delft Blue with a detail mop brush to paint shadows around the salamander's legs. Blend with a damp detail mop brush. Paint the top of the salamander and the salamander's legs with Lyra Lemon Cadmium. Paint feet with Bruynzeel Light Red. Blend with the Lyra Lemon Cadmium. Paint a center stripe with Bruynzeel Light Red, going above and below the masking frisket. Repeat the previous steps for the desired intensity.

Dab Lyra Delft Blue and Bruynzeel Light Green with a small piece of natural sponge for texture. Apply Lyra White on the lower part of the salamander. Allow to dry. Apply Lyra Peacock Blue with a detail mop brush over the same area. Lightly dab the salamander's feet and blend with Lyra Delft Blue and Bruynzeel Light Green. With a no. 3 round brush, paint the eye with the same colors.

Apply Bruynzeel Umber with a detail mop brush to clean up the edges touching the upper rocks. Paint the shadows below the salamander with Delft Blue. Apply Lyra Black Medium with a no. 1 round brush to paint the details around the red blotches on the eyes, mouth line, nose hole and along the center stripe. Dry thoroughly before removing liquid frisket.

Mask the turtle's eye highlight with liquid frisket. With a small piece of natural sponge for texture, dab Bruynzeel Prussian Blue on the chest plates, unscaled face and back leg parts. Allow to dry. Apply Lyra Light Chrome with a ¼-inch (63mm) flat mop brush to paint the back legs, tail, chest plates, head and neck. Allow this to dry, and repeat

for intensity.

Apply Lyra Delft Blue, Night Green and Dark Orange with a slightly wet ¼-inch (63mm) flat mop brush to paint around the edges of the turtle's chest plates. Blend with the flat mop brush. With the same four colors, add details to the scales of the back legs, tail, head and neck using a detail mop brush. Paint the toenails with Lyra Dark Orange. Paint the scales twice with Bruynzeel Light Yellow. Reapply Lyra Light Chrome with a ¼-inch (63mm) flat mop brush to paint the back legs, tail, chest plates, head and neck. Repeat the previous steps to reach the desired intensity.

Apply Lyra Delft Blue and Night Green with a detail mop brush to paint divisions between turtle's chest plates. Blend with a detail mop brush. Paint shadows around the outer shell plates with Lyra Delft Blue. Apply Lyra Wine Red, Dark Orange and Light Chrome to paint the outer shell plates, working dark (inner) to light (outer) and blending with a damp detail mop brush. Repeat to achieve the desired intensity.

Paint the turtle's upper scales on the front fins using Derwent Zinc Yellow with a detail mop brush. Paint around the scales with Lyra Dark Orange. Repeat to achieve the desired intensity. Paint the lower scales on the front fins with Bruynzeel Light Yellow. Paint around the lower scales with Lyra Wine Red and Night Green. Repeat to achieve the desired intensity.

Apply Lyra Delft Blue with a no. 1 round brush to paint the outer part of the turtle's eye. Paint the inner part with Lyra Night Green. Paint the nose hole, mouth line and around the eyes with Lyra Black Medium. Intensify the details with Lyra Night Green. Clean up the edges between the water and the turtle with Lyra True Blue and between the plants and the turtle with Lyra Night Green.

Dampen a natural sponge and dab water around the turtle's fins with Lyra Night Green and Bruynzeel Light Green for motion texture.

Step 5: Make the Border

Create a 2" (5cm) border around the painting by holding a piece of cardboard or other straightedge to mask inner picture.

Dab the entire border edge with Lyra Black Medium, Delft Blue, Wine Red, Dark Orange and Lemon Cadmium applied to a damp, fine-textured natural sponge to create texture. Repeat two or three times for the desired intensity, and allow to dry. Dab with Lyra White using a small piece of medium-textured sponge.

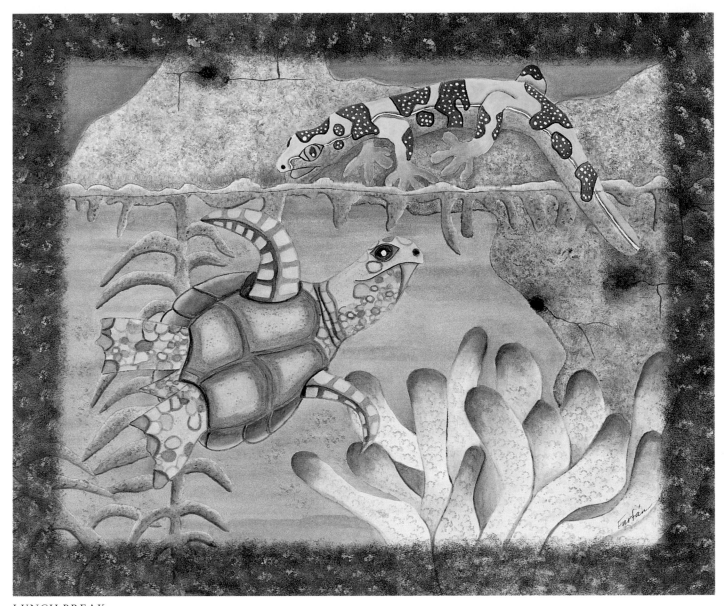

LUNCH BREAK
Rhonda Farfan
20″ × 24″ (50cm × 60cm)
Wet-on-Dry Technique 3

Triplets

by Shane

WET-ON-DRY 3 AND DRY-ON-DRY TECHNIQUES

Shane demonstrates the best of both water-soluble colored pencils and dry colored pencil art, contrasting a loose, subtle look of the background with the vivid, detailed plumage of the main subjects.

MATERIALS

300-lb. (640gsm) Arches cold-press paper
Maskoid frisket
Incredible Nib by Grafix
no. 2 graphite pencil
kneaded eraser
plain bond paper
nos. 2, 3, 8 and 10 round sable watercolor brushes
irregularly shaped natural sponge
watercolor palette or small plastic container for dissolving color

LAYOUT

Wash the paper thoroughly to remove the sizing. Blot, do not rub, the excess water from the paper using a soft cloth (such as a cloth diaper). Tape the paper to a board using masking tape and let this dry overnight. The next day, use a no. 2 graphite pencil to lightly lay out the basic drawing.

Before beginning to paint any particular area, paint a value/hue test on a scrap of paper to be certain the colors are accurate because colors usually dry lighter than they appear when first applied. Apply the wet color to the same type of paper and allow to dry thoroughly.

Color Palette

REXEL DERWENT WATERCOLOUR:

Burnt Umber	Madder Carmine
Cedar Green	Oriental Blue
Deep Cadmium	Sap Green
Deep Chrome	Spectrum Orange
Deep Vermilion	Ultramarine
Geranium Lake	Venetian Red
Indigo Blue	

SANFORD PRISMACOLOR:

Aquamarine	Poppy Red
Canary Yellow	Rosy Beige
Cool Grey 70%	Sepia
Crimson Red	Sienna Brown
Indigo Blue	Spanish Orange
Jade Green	Ultramarine
Peach	Tuscan Red
Peacock Blue	White
Periwinkle	

Step 1: Paint the Yellow Areas

Apply water to the wing feathers and head of each bird (to be yellow) with a no. 8 round brush. Make a mixture of Derwent Deep Chrome and Deep Cadmium by rubbing the pencil with a wet brush into a watercolor tray containing a small amount of water. This same basic technique should be used when creating a wash of color to any area of the painting.

Apply water to the upper and lower beak with no. 2 and no. 3 round brushes. Apply a mixture of Derwent Deep Cadmium, Deep Chrome and a small amount of Geranium Lake.

Step 2: Paint the Background and Foreground Foliage

Apply a large amount of water to the area behind the two parrots on the right and under the parrot on the left. Add water, as necessary, to maintain a wet surface. Dissolve Derwent Oriental Blue and Cedar Green in water. Make an adequate amount of this mixture (approximately ¼ cup in this case). Allowing the paint to flow freely, loosely paint the background trees with a no. 8 and no. 10 brush. Allow to dry. Dip a natural sponge into the paint mixture and daub randomly in the background. Dry thoroughly.

When applying water to large areas in preparation of a wash, it's easier to keep track of where it's been applied by first adding a small tint of color to the water. This color should be the same as the finished wash will be.

Apply water to the entire foreground tree with a no. 8 brush. In separate containers, dissolve Oriental Blue, Venetian Red, Spectrum Orange and Burnt Umber in small amounts of water. With the same brush, drop small, random amounts of these four colors into the pre-moistened areas. Allow to dry undisturbed.

Lightly draw long leaves on the smaller branches with a no. 2 graphite pencil. Apply water to each leaf shape with a no. 3 brush. Rub the tips of the Derwent Sap Green and Cedar Green pencils with a moistened brush and drop colors into the moist leaf shapes. Allow this to dry, and erase the graphite lines.

Step 3: Mask the Leaves and Parrots

Mask the leaf shapes on the main tree branches with the Incredible Nib. Cut masks out of plain bond paper to cover each parrot. Lightly tape over the parrots to keep them free of color during the next operation.

Dissolve Cedar Green plus small amounts of Burnt Umber and Indigo Blue in a watercolor tray. Test the mixture on paper to adjust the value. Load the natural sponge with the paint mixture. Daub random shapes in the background on dry paper for the distant trees. Allow to dry. Make additional distant tree shapes around the parrot tails with a no. 8 brush. With the same color, add the shapes of the tree trunks with a no. 3 brush.

Dissolve Burnt Umber and Venetian Red in two separate containers with a small amount of water. With no. 3 and no. 8 brushes, add wood grain details to the main tree. To accomplish this effect, use a small amount of pigment and drag it across a dry surface. The rough surface of the paper will create the texture.

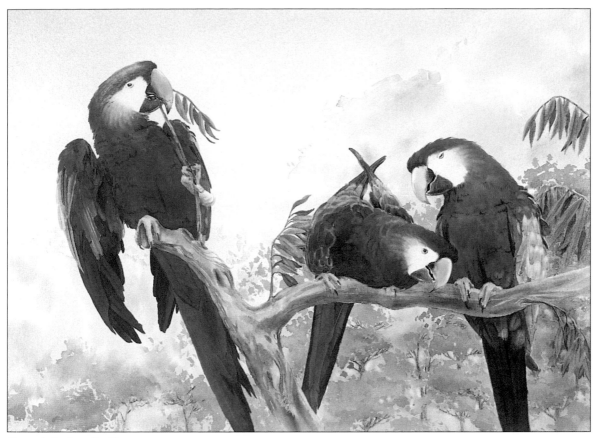

Step 4: Paint the Parrots

Apply Derwent Deep Vermilion, Madder
Carmine and Geranium Lake to the feathers
and bodies of the parrots with a wet no. 3 or
no. 8 brush—the smaller brush is used for
the small feathers on the body and head, and
the larger brush is used on the larger tail and
wing feathers.

Apply Madder Carmine, Deep Cadmium,
Spectrum Orange, Indigo Blue, Oriental Blue
and Ultramarine to depict the under-wing
feathers of the parrot on the left and the top
wing feathers on the center and right birds.
Make sure the wing tips and tail feathers are
dry, then darken them with glazes of Madder
Carmine, Burnt Umber and Venetian Red.

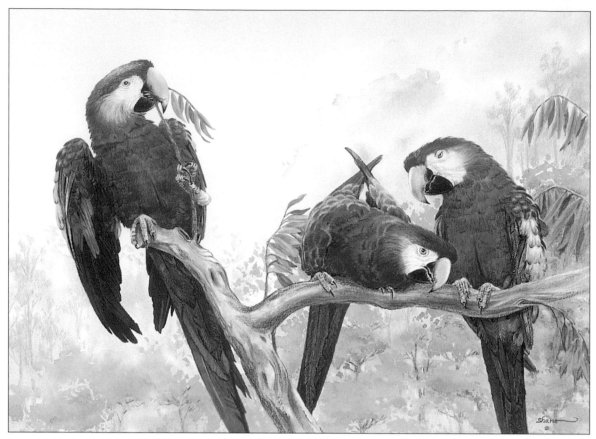

Step 5: Paint the Details With Wax-Based Colored Pencils

Sanford Prismacolor pencils are used throughout this step. Apply Ultramarine, Peacock Blue, Aquamarine, Periwinkle and White to create blue wing-feather details. Apply Canary Yellow, Spanish Orange and White for the yellow feathers. Apply Aquamarine and Indigo Blue to the tips of the yellow feathers.

Apply Poppy Red, Crimson Red and White for the small feathers of the heads and bodies. Apply Tuscan Red and Sepia to create shadows in the feather layers. Apply Cool Grey 70% and Indigo Blue for the creases in the feet and skin details. Apply Rosy Beige and White for the fleshy pads of the toes. Apply Indigo Blue to part of the beak, claws and pupils of the eye.

The light area around the eyes of this species of parrot (the Scarlet Macaw) is not made up of feathers but rather a wrinkled, soft skin. Create this effect with soft lines of Peach and Rosy Beige.

Apply Sienna Brown, Jade Green and Sepia to enhance the wood grain detail in the tree trunk and branches. Apply Jade Green and a glaze of White over the distant trees below the parrots on the left and right sides to soften the edges and lighten values.

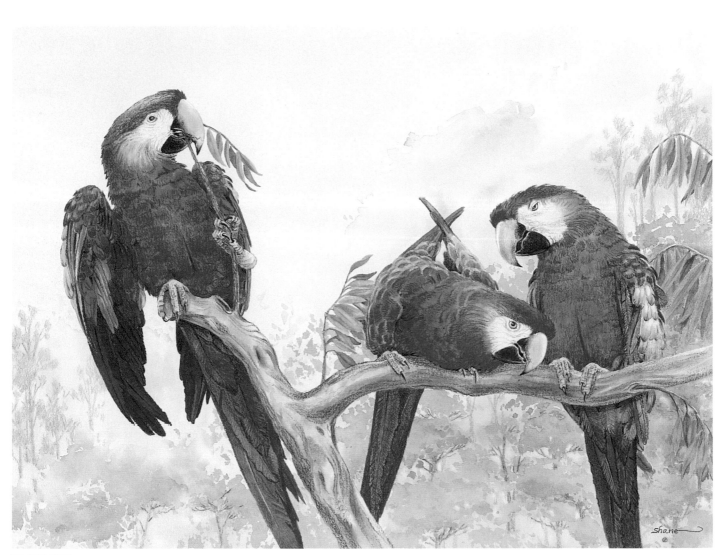

TRIPLETS
Shane
14½" × 19⅝" (37cm × 49cm)
Wet-on-Dry and Dry-on-Dry Techniques

Vintage Study 2
by Gary Greene
VARIOUS TECHNIQUES

This portion of a deteriorating automobile utilized several techniques including wet-on-wet, wet-on-dry pencil, wet paint on paper and dry pencil.

MATERIALS

22″ × 30″ (55cm × 75cm) 300-lb. (640gsm) Arches rough watercolor paper

no. 14 flat brush

nos. 4, 6, 8 and 10 round watercolor brushes

watercolor palette or small plastic container for dissolving color

X-Acto knife

no. 16 X-Acto knife blades

paper towels

LAYOUT

Watercolor paper was washed in the sink and rinsed thoroughly to remove the sizing, then the original transparency was projected onto the paper and the image was traced with a Derwent Silver-Grey water-soluble pencil.

Color Palette

CARAN D'ACHE SUPRACOLOR II:
Greyish Beige

FABER-CASTELL ALBRECHT DÜRER:
Cold Grey III, IV, V, VI
Warm Grey I

LYRA REMBRANDT AQUARELL:

Brown Ochre	Light Orange
Burnt Ochre	Paris Blue
Cool Silver-Grey	Raw Umber
Dark Sepia	Sky Blue
Indian Red	Van Dyke Brown
Light Blue	

REXEL DERWENT WATERCOLOUR:
Chocolate
Silver-Grey

Step 1: Apply the Wash

Break off several points of Lyra Light Blue and Cool Silver-Grey pencils and place them in separate watercolor palettes. Moisten the points with water and allow them to soak for approximately thirty minutes. Stir with a small brush.

Use a no. 14 flat brush to lightly wet the area shown with water. Apply liquefied Light Blue with a no. 14 flat brush. Apply liquefied Cool Silver-Grey in the darker area with a no. 14 flat brush. Allow to dry overnight.

Apply a layer of Lyra Cool Silver-Grey to the gray textured area. (Remember: Pencils will wear down quickly when applied dry to rough paper surface.) Apply a layer of Faber-Castell Cold Grey IV to the darker curved edge. Wet with a medium-wet no. 6 brush and redraw the layout lines as necessary.

Step 2: Paint the Fender

Randomly apply Lyra Light Orange to the fender area. Apply water with medium-dry no. 8 round brush. Dry with a hair dryer or allow to air dry.

Break off several points from a Lyra Sky Blue pencil and place them in palette cup(s). Add water and allow to stand overnight. Unevenly apply the liquefied Sky Blue from the palette with a saturated no. 10 round brush, using vertical strokes and overlapping the edges of the orange areas. Allow to dry overnight and repeat the process.

Apply dry Lyra Sky Blue pencil around the edges of the orange areas, allowing the orange to show through. Lightly apply dry Lyra Paris Blue pencil to the blue areas, using the heavy texture of the paper to depict the uneven texture of the fender. Lightly scrape away small areas of blue with a sharp no. 16 X-Acto knife, being careful not to damage the paper surface. Apply Lyra Light Orange to the scraped areas. Apply water with a moist no. 6 brush. Apply Lyra Paris Blue, Van Dyke Brown, Dark Sepia, Faber-Castell Cold Grey VI and IV to dark areas as shown. Apply water with a no. 6 moist round brush. Apply Lyra Sky Blue and Faber-Castell Cold Grey IV to the edge of the fender cut-out.

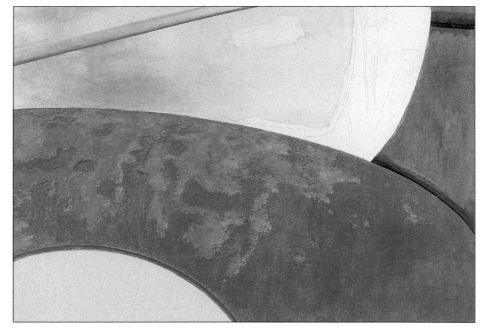

Step 3: Paint the Rust, Scrapes, Holes and Wheel Well

Apply Faber-Castell Cold Grey V, IV and III with a no. 4 round brush to the dark gray areas on the side of the hood. Dry with a hair dryer. Reapply if necessary. Apply Lyra Indian Red and Burnt Ochre to the rust areas on the hood. Apply water with a moderately wet no. 4 brush. Dry with a hair dryer. Layer Lyra Dark Sepia dry to the rust areas.

Randomly apply Faber-Castell Cold Grey V, IV and III, Lyra Sky Blue, Raw Umber, Brown Ochre, Burnt Ochre, Derwent Chocolate, Caran d'Ache Greyish Beige and Faber-Castell Warm Grey I with a moderately dry no. 6 or no. 8 brush to the area between the hood and body. Dry each layer of liquid color with a hair dryer before adding the next. Reapply color to achieve the desired effect.

Apply Lyra Indian Red and Burnt Ochre to the area between the hood and body. Apply water with a moderately wet no. 4 brush. Dry with a hair dryer. Layer Lyra Dark Sienna dry to the rust areas.

Apply Lyra Raw Umber to bolts. Apply water with a damp no. 4 brush. Dry with a hair dryer. Layer Lyra Dark Sienna dry. Apply Lyra Dark Sienna to the shadows, holes and space between the hood and body with a no. 4 or no. 6 brush. Dry with a hair dryer. Reapply if necessary. Break off four or five Lyra Dark Sienna pencil points, place in a palette cup filled with water and allow it to stand overnight. Apply Lyra Dark Sienna to the wheel-well area with a no. 10 brush. Dry with a hair dryer. Reapply if necessary.

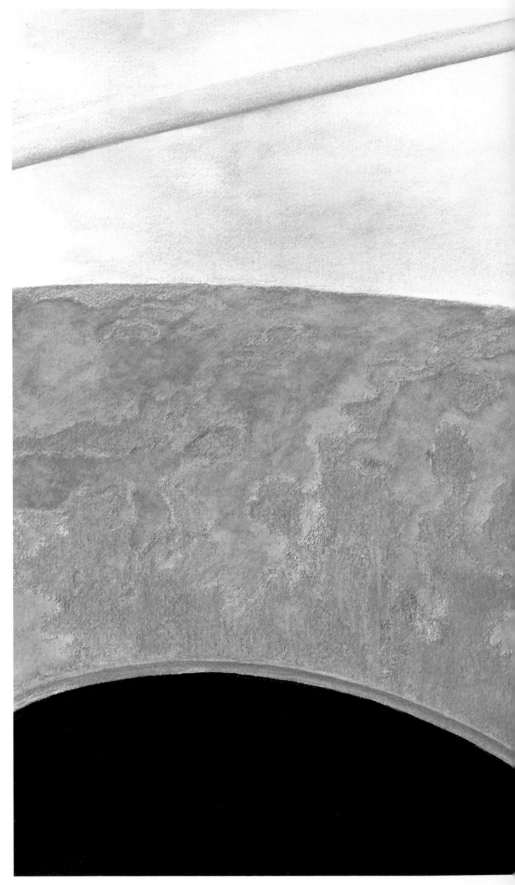

VINTAGE STUDY 2
Gary Greene
16½" × 23" (41cm × 57cm)
Various Techniques

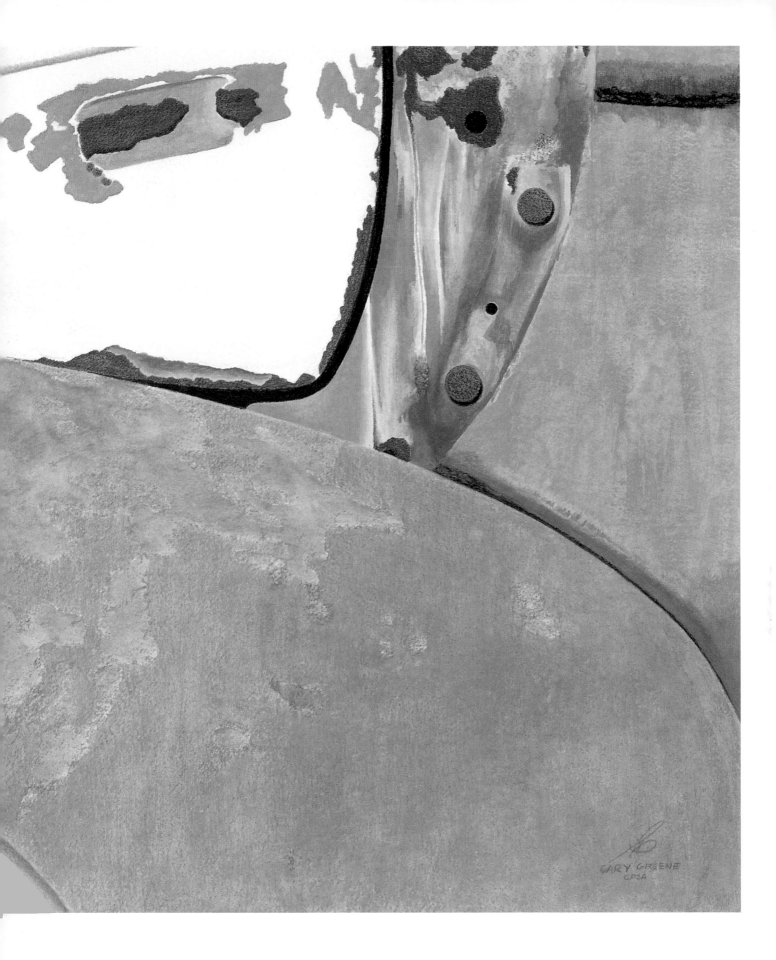

City Street Scene
by Dyanne Locati
WET-ON-WET TECHNIQUE 2

Dyanne's imagination was working overtime when she created this evocative abstract. A portion of the color was applied first, and then figures were cut out of the newspaper and used as masks while more color was applied to the painting.

MATERIALS

11″×14″ (28cm×35cm) Arches 300-lb. (640gsm) watercolor paper
scrap museum board
Mylar plastic
no. 10 round watercolor brush
natural sea sponge or a soft household sponge
no. 2 graphite pencil
vinyl eraser
figure shapes from newspaper

Color Palette

FABER-CASTELL ALBRECHT DÜRER:

Azure Blue	Juniper Green
Burnt Ochre	Lemon Cadmium
Canary Yellow	Light Cobalt Blue
Cobalt Blue	Night Green
Delft Blue	Phthalo Blue
Gold Ochre	Sanguine
Grass Green	Sap Green
Hooker's Green	Tangerine
Indian Red	Vermilion

LYRA REMBRANDT AQUARELL:

Dark Carmine	Prussian Blue
Moss Green	Sap Green
Night Green	Viridian
Olive Green	

Step 1: Establish Underpainting

Wet the paper with a no. 10 round brush, rewetting if it dries. Dip pencil points in water. Use the side of the pencil with vertical strokes to randomly apply Faber-Castell Hooker's Green, Grass Green, Night Green, Delft Blue, Light Cobalt Blue and Azure Blue. Use Lyra Prussian Blue, Night Green, Viridian, Sap Green and Moss Green. Leave some white areas.

Step 2: Draw Shapes

Cut figure shapes out of a newspaper or magazine. Place these shapes on the previously painted art. Create an interesting horizon line with the heads of the figures—the horizon line will balance the vertical lines in step 1. Draw around the shapes with a no. 2 graphite pencil.

Wet shapes behind the figures on the right side of the page with a no. 10 round brush. Rewet the area if necessary. Dip the pencil points in water and use the side of the pencil to apply Lyra Night Green, Prussian Blue, Faber-Castell Delft Blue, Burnt Ochre and Gold Ochre. Leave the shapes of buildings and doorways light.

Wet the areas under the figures on the right side of the page and apply the same colors. Wet the figure shapes. Apply Faber-Castell Burnt Ochre, Sanguine and Canary Yellow beside the cool colors. Place warm colors *beside* cool colors, not on top of them. Mixing warm and cool will create muddy colors.

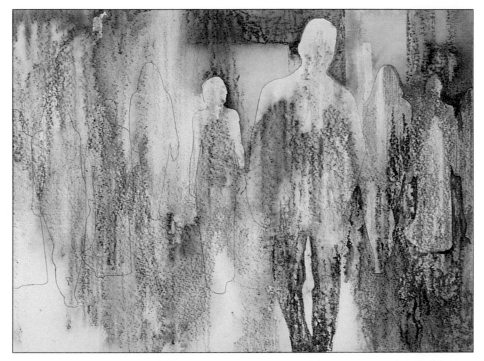

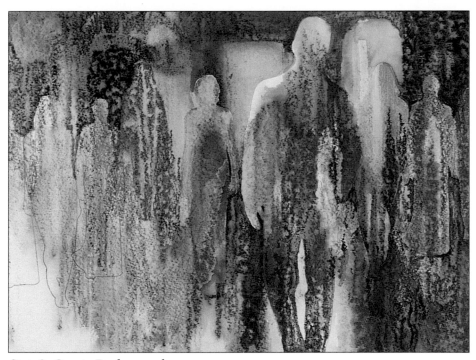

Step 3: Create Background

Wet paper with a no. 10 round brush. Rewet if it dries. Dip pencil points in water. Apply the same colors as in step 2 to vertical texture shapes. Work dark areas against light areas. Do not leave figures in silhouette. Allow the light areas to show through.

Make a paper palette by creating color swatches on a separate piece of scrap museum board with Faber-Castell Lemon Cadmium, Canary Yellow, Gold Ochre, Tangerine, Vermilion, Indian Red, Prussian Blue, Night Green, Cobalt Blue, Juniper Green, Phthalo Blue, Azure Blue, Sap Green, Grass Green, Lyra Dark Carmine, Night Green and Olive Green. Wet large areas without textures—this will achieve a smooth look. Dab the wet brush on a household sponge to control water in the brush.

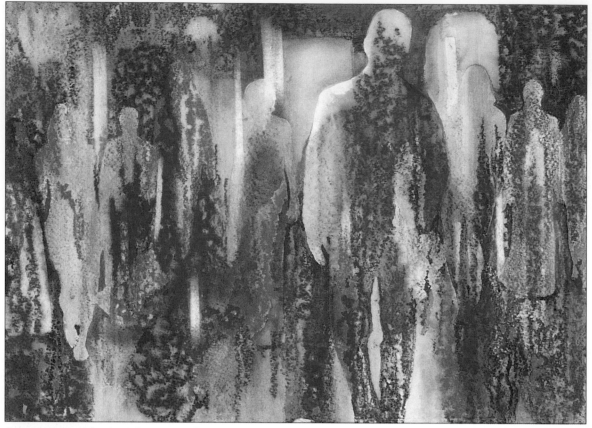

Step 4: Paint the Finishing Touches

Erase the graphite lines with a vinyl eraser. Anchor the figures' feet to the street by applying the same color from the figure to the area below.

Create highlights by placing two pieces of Mylar plastic on your art. Leave the areas to be lightened exposed, and wet them with a no. 10 brush. Wet a soft sea sponge and wring out the excess water. Rub exposed areas with the damp sponge. Remove the Mylar and dab with a paper towel.

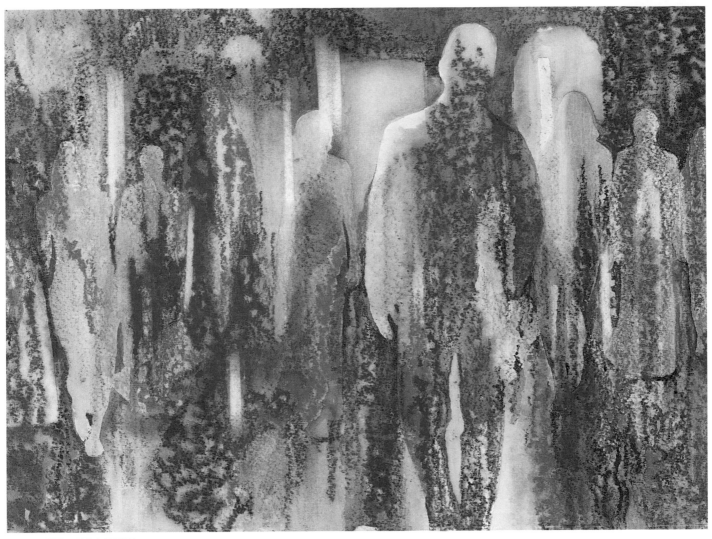

CITY STREET SCENE
Dyanne Locati
11″×14″ (28cm×35cm)
Wet-on-Wet Technique 2

Orbs

by Rhonda Farfan

WET-ON-DRY TECHNIQUE 3

In this cleverly conceived abstract, Rhonda used a number of materials and variations of wet pigment on dry paper, including wetting sponges and brushes with water-soluble colored pencils tips, splattering and using a brayer on puddles of color.

MATERIALS

24" × 20" (60cm × 50cm) Crescent 100 percent rag illustration board

20" × 16" (50cm × 40cm) piece of cardboard

straightedge with mat board glued to the back

1-inch (2.5cm) brush

no. 1 round brush

1-inch (2.5cm) polyfoam brush

¼-inch (63mm) mop brush

no. 2 graphite pencil

toothpick

liquid frisket

plastic pickup

1½" no. 70 rubber brayer

assorted natural cosmetic sponges

LAYOUT

A simple drawing was done directly on the paper using a no. 2 graphite pencil. Circular objects of various sizes, such as container lids, were used to draw the circles. A two-inch border was included as part of the drawing.

Two techniques were used here. Wetted water-soluble pencil tips were applied to wet brushes or sponges, and either applied to dry paper or splattered directly onto the paper. Wetted water-soluble pencil tips and brushes were used to create puddles of color that are pushed onto the paper with a brayer.

Color Palette

BRUYNZEEL DESIGN AQUAREL:
Light Yellow
Yellow-Green

LYRA REMBRANDT AQUARELL:

Dark Orange	Night Green
Delft Blue	Peacock Blue
True Blue	Prussian Blue
Lemon	Wine Red
Light Green	

REXEL DERWENT WATERCOLOUR:

Indigo Blue	Jade Green
Ivory Black	Madder Carmine

Step 1: Create the Background

Apply liquid frisket along the border edge with a 1-inch (2.5cm) polyfoam brush, using a straightedge with a piece of mat board glued or taped to the underside.

With a ½-inch (1.3cm) mop brush wetted with liquid frisket, splatter frisket around the orbs by drawing a toothpick across the bristles. Allow to dry. Remove any liquid frisket splatters from the diagonal stripes with a plastic pickup. Cover the orbs with liquid frisket using a ¼-inch (63mm) mop brush for the small orbs and a 1-inch (2.5cm) brush for the larger orbs.

Wet the pencil tips with a wet 1-inch (2.5cm) mop brush and apply color in a puddle. With a soft rubber brayer, roll the puddle out until smooth. Repeat, laying colors side by side and above one another until the entire background is full. Apply pigment in the following order: Lyra Delft Blue, True Blue, Peacock Blue, Derwent Madder Carmine, Lyra Dark Orange, Bruynzeel Yellow-Green and Lyra Lemon. Rinse your brayer occasionally between layers and change your water when it becomes muddy. Repeat this process twice.

Mask diagonal stripes with liquid frisket using the straightedge for clean edges. Add more splatters of liquid frisket with the ¼-inch (63mm) mop brush and a toothpick. Allow to dry.

Repeat the puddle and brayer procedure to achieve the desired intensity. When dry, remove all liquid frisket with a plastic pickup.

Step 2: Paint the Orbs

Paint a border of liquid frisket around the outside of the orbs with a 1-inch (2.5cm) polyfoam brush.

Moisten the pencil and apply it to the damp sponge, then dab the colors in the following order from the outside of the lighter-colored orbs inward: Derwent Indigo Blue, Lyra Night Green, Wine Red, Prussian Blue, Derwent Jade Green, Lyra Light Green and Bruynzeel Light Yellow. Change the water when muddy. Dry between layers.

Change from a medium-textured to a fine-textured sponge. Repeat the above procedure to achieve the desired intensity. Use the Lyra Wine Red only on the first procedure.

With a medium-textured sponge, moisten the pencil, apply it to the damp sponge and dab on the following colors from the outside of the darker-colored orbs inward: Derwent

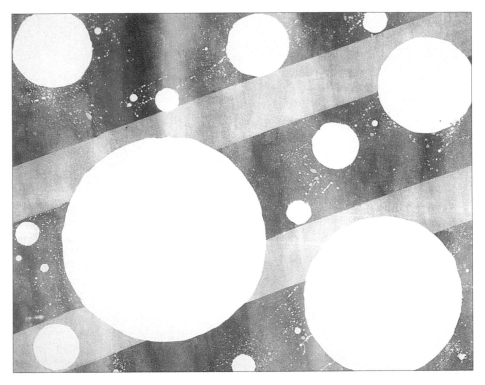

Ivory Black, Derwent Indigo Blue, Lyra Delft Blue, Lyra Prussian Blue. Change the water when muddy. Dry between layers.

With a fine-textured sponge, repeat the above procedure to achieve the desired intensity. Allow to dry thoroughly. Remove the

frisket with a plastic pickup.

Apply Derwent Indigo Blue and Lyra Night Green with a no. 1 round brush on the edges of the light orbs. Apply Derwent Indigo Blue and Lyra Delft Blue with the same brush on the edges of the dark orbs.

Step 3: Paint the Border

Mask the painting with a piece of cardboard cut to the size of the image, leaving the border exposed.

Apply color from the pencil tips used in steps 1 and 2 to a wet ¼-inch (63mm) mop brush. Splatter color on the border by drawing the wet pencil across the brush bristles, allowing droplets of paint to fall onto the border. Apply each color once. Change the water when it becomes muddy.

ORBS
Rhonda Farfan
20″ × 24″ (50cm × 60cm)
Wet-on-Dry Technique 3

Bonnie Auten, CPSA

Bonnie Auten believes her realistic colored-pencil paintings are collaborations between herself and God. The Lord deposits an image in her spirit that is clear and concise. She re-creates this image, striving for a "spirit of excellence" in her artwork. Executed with excellence, the theme the Lord has given her will impact the viewer—catch the eye and hold the heart.

Being colorblind, or color recessive, Bonnie misinterprets varied color intensities. To compensate for this, color becomes secondary to powerful compositions with strong value contrasts.

Bonnie's work has been included in many national and international exhibitions, including every Colored Pencil Society of America (CPSA) International Exhibition. In 1993 she was winner of the Member's Award, and in 1995 she received the highest honor with the Outstanding Recognition of Excellence Award. Bonnie was one of the first twelve artists in the CPSA to win Signature Status for her work in colored pencil. Currently she is president of CPSA District Chapter 104 in the Detroit area.

Her awards also include the Grande Award in the Akron Society of Artists Grande Exhibition in 1996 and Third Place in the Realism 1995 Exhibition. She has received Honorable Mention in *The Artist's Magazine* cover contest twice and was recognized as Finalist in the 1997 Art Competition in *The Artist's Magazine*. A Crabby Award was received for her artwork from *Art Calendar Magazine* in 1995 and 1997. Bonnie's work is in *The Best of Colored Pencil 1, 2, 3,* and *4*. *Portrait Inspirations* by Rockport Publishing and *Colored Pencil Techniques* by Vera Curnow also feature her art. Her work has been published in *The Artist's Magazine*, as well as *North Light Magazine*.

Pat Averill, CPSA

Pat became interested in art while doodling profiles of her classmates in grade school. She has found solace in drawing, painting and photography. Her mediums of choice are casein, oil and colored pencil. After being introduced to colored pencils in the early 1980s, she quickly became hooked on them.

Pat's techniques include loose layering allowing the translucence of pencil layers to mimic complex colors found in nature. She likes to burnish with lighter colored pencils over the top or between layers of color until it looks like an oil painting. Pat occasionally underpaints with layers of colored pencils dissolved with solvent or with water-soluble colored pencil washes. Her paintings may take from 30–200 hours to complete.

Pat has been published in *The Best of Colored Pencil 1, 2,* and *3, Creative Colored Pencil* and *Creative Colored Pencil Landscapes* by Vera Curnow (Rockport Publishers).

Her colored pencil paintings have won local, national and international awards, including the Canson Talens Award at the fifth International Colored Pencil Exhibition, Chicago; First Place for Colored Pencil and Best of Show at the Lake Oswego Festival of Arts; and First Place at the Newport, Oregon, Visual Arts Center. Her work has been juried into exhibitions throughout the U.S., and she has exhibited in numerous galleries.

Pat achieved Signature Status in the Colored Pencil Society of America after having been juried in the first three international exhibitions sponsored by the group. She served for two years as president of Oregon's CPSA District Chapter 201. The latest venue is teaching ongoing classes, workshops and a correspondence class.

Rhonda Farfan

Rhonda Farfan, a life-long artist, has been working in colored pencil for more than ten years. Prior to using colored pencils, Rhonda's tool of choice was the airbrush, which familiarized her with the masking and texturing techniques associated with aqueous materials.

Rhonda's background also includes cartooning, printmaking and working with acrylics, but once introduced to the medium of colored pencil she never looked back. The intimacy and versatility of this medium is captivating.

Rhonda's work has been in numerous solo and group shows, including the Colored Pencil Society of America's (CPSA) International Exhibition. She has conducted workshops and done demonstrations. Rhonda's work has also been published in *To The Point* the national newsletter of the CPSA, *The Best of Colored Pencil 1, 2, 3* and *4* (Rockport), *Illustration* (Rockport), *Creative Colored Pencil* (Rockport). She has had articles in *The Artist's Magazine, Pen, Pencil, Paint* (the newsletter of National Artists Equity Association), and *Art Calendar*.

Rhonda has been the Product Research Director for the CPSA since 1991 and has been testing colored pencils for lightfastness for more than five years. Her current priority is to see lightfastness standards established for the colored pencil. She is currently the president of the CPSA.

Dyanne Locati, CPSA

Dyanne Locati has studied art at Portland State University, Clackamas Community College, Marylhurst College and Oregon College of Art and Craft all in the Portland, Oregon, area. As the administrator and former owner of the Locati Creative Art Center, she has conducted, coordinated and organized workshops and classes in all media. Dyanne teaches classes in watercolor, colored pencil and acrylic for many groups and organizations throughout the country. She also juries exhibitions, directs critique sessions and performs demonstrations.

Dyanne is a signature member of the Color Pencil Society of America (CPSA) and is active in art organizations such as the Watercolor Society of Oregon and the Oregon Society of Artists. She played an important role in the development, structure and formation of the CPSA, serving on the board of directors as executive vice president for six years and Exhibition Director for five years. Currently, she is president of CPSA District Chapter 201 based in Portland, Oregon. She's also vice president of the Watercolor Society of Oregon and the WSO 1998 Fall Exhibition Chairperson in Newport, Oregon.

Dyanne's work has received many awards and honors, appearing in juried exhibitions, and invitationals. Her work has appeared in *The Encyclopedia of Colored Pencil Techniques*, on the cover of *L' Encyclopedie Du Crayon De Couleur*, *The Best of Colored Pencil 1, 2*, and *3*, including the cover of volume 4 and *Creative Colored Pencil: The Step-By-Step Guide & Showcase*.

Her work is represented by Artist's Gallery 21, Vancouver, Washington, the Portland Pendleton Shop and the Portland Art Museum Sales Rental Gallery, Portland, Oregon.

Bernard Aime Poulin

For more than twenty years Bernard Poulin's international portrait career has earned him an enviable reputation. His powerful yet elegant portraits grace the walls of private and corporate collections throughout the world. He has painted members of royalty, the clergy, the judiciary, senators, key academic figures and corporate chief executives.

A master at rendering likenesses, Poulin's brushstrokes, nonetheless, emphasize individual personality traits, which accentuate the unique qualities of his portrait subjects. Children and adults alike are rendered with sincere affection and respect, hallmarks of Bernard Poulin's empathy for those he paints.

Though his first love is portraiture, Poulin excels in the rendering of vibrant landscapes and still life's. His well-rounded talent and renaissance perception of his profession encourage his constant experimentation in alkyd oils, pencil, watercolor and sculpture.

A designer and sculptor, the artist has created several donor-recognition walls and three-dimensional murals in wood, marble, acrylic and bronze.

A much sought after lecturer, his workshops and presentations are sold-out events. Poulin has taped several educational television programs which subsequently were translated and distributed internationally. He has written articles for professional art magazines and is the author of seven books on drawing techniques. North Light, of Cincinnati, Ohio, published his last five books. His book *The Complete Book of Colored Pencil Techniques* was translated in Paris, France.

Recipient of several awards of merit, Bernard Poulin is also a member of the American Society of Portrait Artists, the Bermuda Society of the Arts, the Colored Pencil Society of America and is listed in the Who's Who of Canada. The artist is most proud of the two "Bernard A. Poulin Scholarships," created by the Hadassah-Wizo Association of Canada in 1990.

Shane

Shane has been involved in the fine arts for many years. She has been an instructor to people of all ages and has the ability to involve them in the wonder of art. Her primary love has been watercolor although she has used most of the media in her works. Most recently she has been involved in furthering her education to include the use of colored pencil.

Shane's subjects range from portraits done in pastel, charcoal and oil, to florals and wildlife painted in watercolor and colored pencil.

Shane is a member of the Northwest Watercolor Society (NWWS) and the Colored Pencil Society of America (CPSA). She has numerous paintings in private collections one of which is on exhibit at the Seattle Fire Department Fire Alarm Center. She also has shown her works throughout western Washington and has been accepted into many regional juried shows, recently including the 1996 Edmonds Art Festival. Also, in 1996 her colored pencil drawings were shown at the Washington State Convention Center in Seattle.

Her work is featured in *Artist's Photo Reference: Flowers* by Gary Greene, published by North Light Books.